BROWN
BEARS

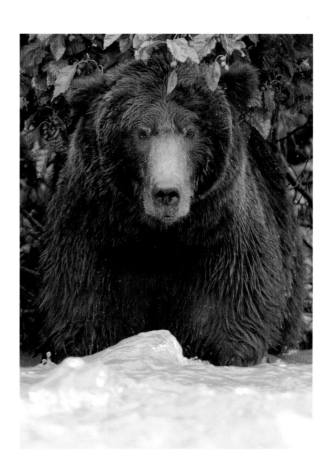

First published in the
United Kingdom in 2010 by
Evans Mitchell Books
54 Baker Street
London W1U 7BU
United Kingdom
www.embooks.co.uk

Design by
Darren Westlake
TU ink Ltd, London
www.tuink.co.uk

British Library Cataloguing in Publication Data.
A CIP record of this book is available
on request from the British Library.

ISBN: 978-1-901268-50-8

Printed in China

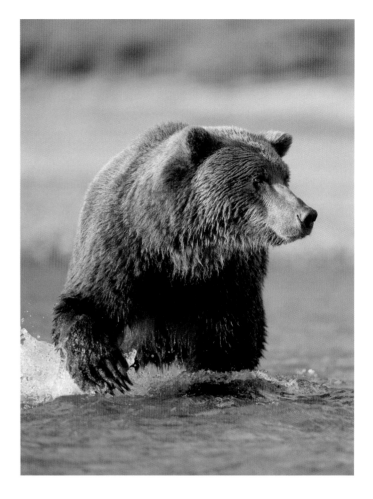

BROWN
BEARS

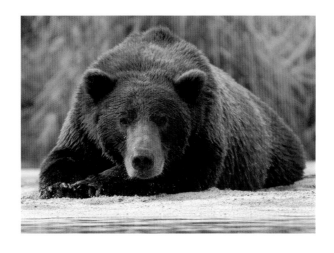

CHRIS WESTON

Evans Mitchell Books

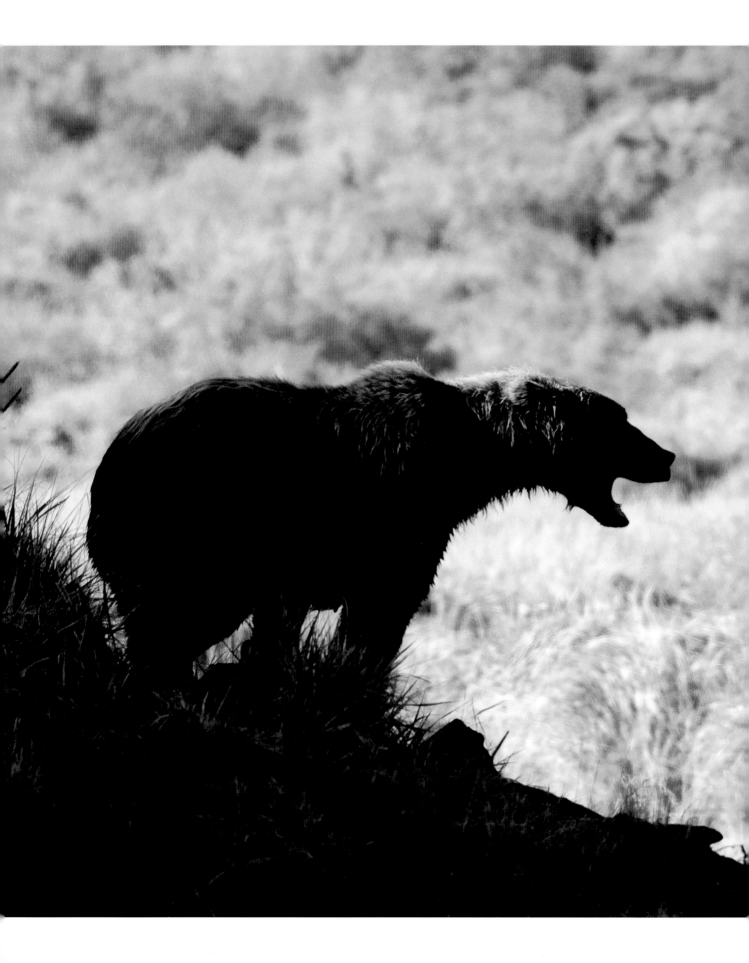

Contents

Introduction 7

Evolution 12

A year in the life 16

Distribution 28

Habitat 32

Taxonomy 38

Behaviour 50

Reproduction 64

Bears in the environment 74

Bears and humans 82

Conservation 86

Watching bears 88

Bear facts 92

Useful information 94

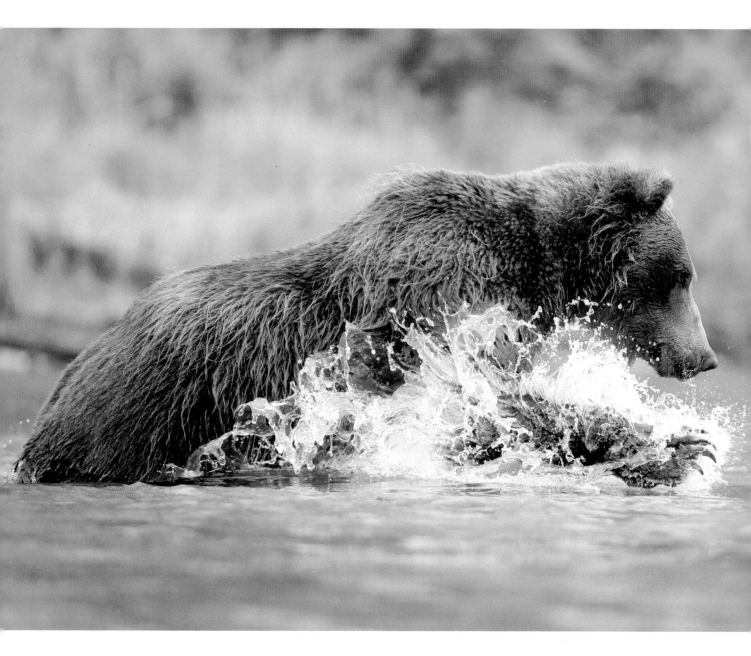

Above: Far from being unpredictable, bears, like most animals, are driven by instinct.

Right: I was able to successfully predict this photograph of a bear catching a salmon thanks to the expert knowledge of my biologist guide.

Introduction

I have had a deep fascination for brown bears ever since I first stood thigh-deep in the middle of Brooks River, Alaska, my camera in my hand.

With me that day was a young bear biologist, a fellow Brit named Chris Morgan. 'People say bears are unpredictable,' he said to me. 'But they're not.' Turning to scour the river he added, 'Watch this.' A couple of minutes later, he pointed quickly to an adolescent bear and whispered, 'In less than five seconds, that bear will leap for a salmon.'

I wasn't sure whether to believe him or not, but I didn't have to wait long to find out. After four seconds the bear exploded in a flurry of power and surprising agility, emerging moments later from below the surface of the water with a large, plump salmon caught securely between its jaws. 'You see,' Chris said. 'It's not that bears are unpredictable, it's simply that few people *understand* them.'

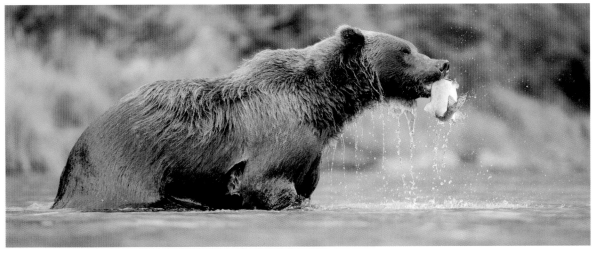

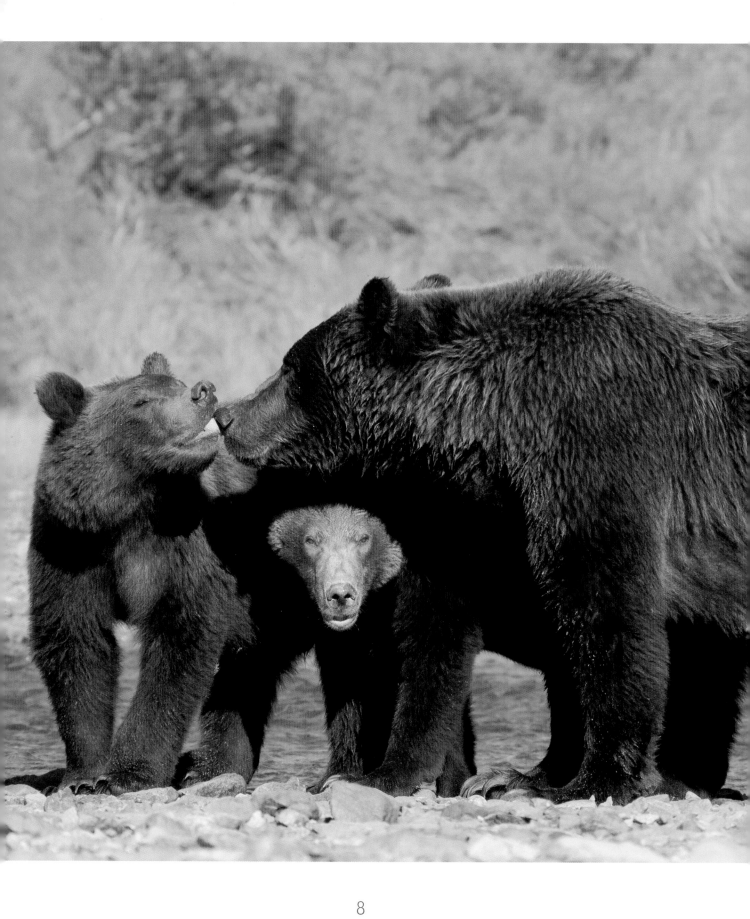

This lack of understanding has moulded our relationship with bears over the centuries. Native Americans recognised in bears many of their own values – an underlying gentleness balanced by the capacity to be fearsome, a caring and dedicated parent and a mighty warrior. Early Europeans didn't share these views and, by the time they reached the New World, they had already eradicated brown bears from much of their own continent. Even today, people's perceptions of bears are mixed and divided.

But for anyone who has studied and watched bears, there is no doubt about their special place in our history and in the ecology of Earth. Like us, they are a relatively new species that has had to adapt quickly in order to survive. That they have done so, in the face of often fierce competition, is testimony to their resilience.

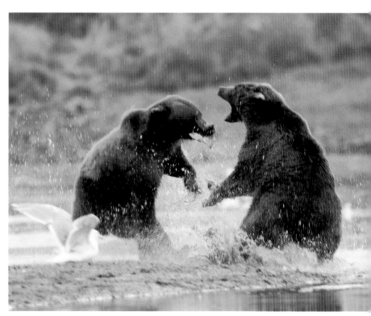

Above: Bears can appear fearsome, but confrontations rarely end in severe injury.

Left: Female bears are caring and dedicated mothers.

I am one who has had the privilege of sharing time and space with bears. Through observation I have learned much about the species and, in no small way, about myself. I am a photographer, not a biologist. In order to capture my images of wildlife, I must close my eyes to the human world and see through the eyes of my subject. Because of that, what you will find reading through the following pages is not pure science – indeed, often what we have at one time believed to be scientifically true turns out to be false; what we think we know and what we actually know are rarely the same thing.

Instead I give you feelings and beliefs, observations and thoughts, anecdotes and testimony, through which I hope that, as well as learning about bears, you will also revel in their mysteriousness and, like me, come to understand them; to admire and respect them for the gentle giants they are.

Right: Playful in nature, bears are true gentle giants of the land.

10

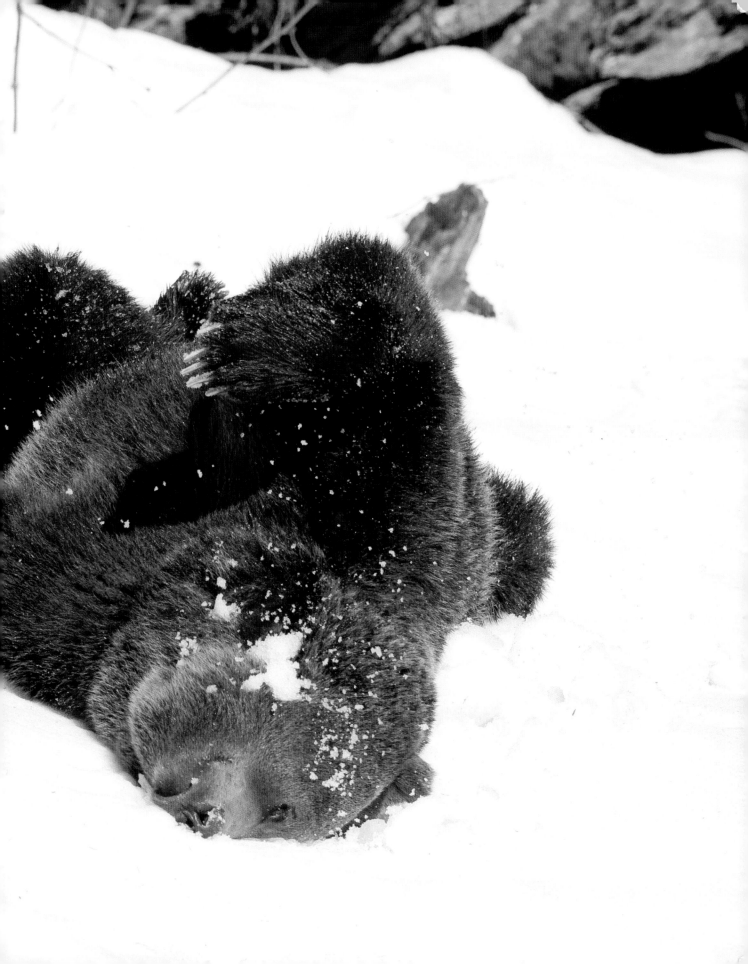

Evolution

If humans had been around 20 million years ago (mya), had they ventured into the then subtropical forests of the land we now call Europe, they might well have encountered *Ursavus*, a dog-like, thick-furred animal with sharp teeth adapted for tearing and ripping. *Ursavus* wasn't a particularly intimidating creature, its diet consisting mainly of insects, small mammals and vegetation, but it was to evolve into some of the modern world's largest carnivorous mammals – bears.

Ursavus is the first recognised species of 'true bear' and is believed to have existed in Africa, Asia and Europe (the Old World) during the Miocene epoch (23.03–5.33 mya), eventually crossing into North America. During the early Miocene the lineage split into two subfamilies. One of these, Indarctos, ultimately evolved into the giant panda (*Ailuropoda melanoleuca*). The other, Agriotherium, was more predatory in nature and diverged further into the family Ursidae.

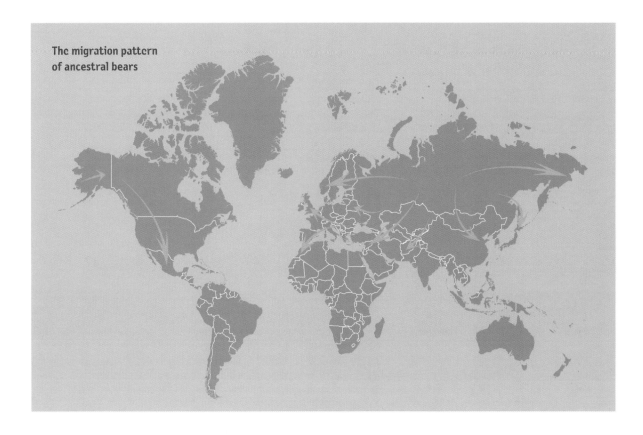

The migration pattern of ancestral bears

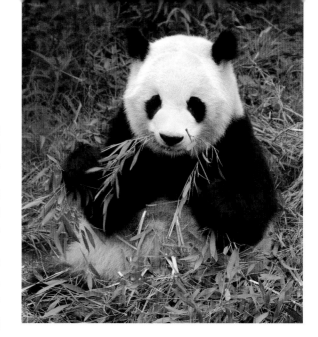

Right: Giant pandas evolved from *Indarctos*, a relative of the first true bear, *Ursavus*.

Below right: The spectacled bear is the only surviving relative of the Tremarctinae.

Ursidae continued to evolve, splitting into two new groups, Tremarctinae and Ursinae. Tremarctinae crossed into the Americas (the New World) about 15 mya, eventually becoming extinct in the Old World. The New World group then became isolated as sea levels rose, and it too died out in North America towards the end of the Pleistocene epoch (2.59 million–12,000 years ago). Today, the only remaining relative of this side of the family is the spectacled bear (*Tremarctos ornatus*), found in South America.

The genus *Ursus*, from which brown bears derive, first appeared during the Pliocene epoch (5.33–2.59 mya), originating most likely in Eurasia. Bears in this family migrated east and south across Asia and then the first ancestral Ursine bear crossed into the Americas about 3.5 mya, evolving into *Ursus americanus* – the American black bear we know today.

Brown bears evolved from another *Ursus* species, *U. etruscus*, about 1.6 mya. The oldest known fossils were found in France and date back around 900,000 years. Other fossil evidence indicates that brown bears were also present in China at least 500,000 years ago. This population continued to expand across Asia and eventually followed the black bear across the region then known as Beringia (northeastern Siberia and Alaska) into North America.

This was a period of historic climate change, where landmasses became connected by land

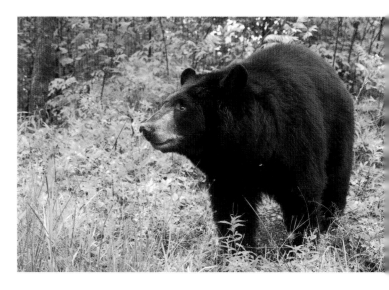

Above: The American black bear is a descendant of the first ancestral Ursine bear to cross into North America from Eurasia.

bridges (the Bering land bridge linked what are now Siberia and Alaska) that would later flood and disappear. It was also the time of the giant mammals, with which bears had to compete – e.g. the sabre-toothed tiger, the North American lion and the giant short-faced bear (a member of the Tremarctinae lineage). During this time numerous species of bear evolved and then became extinct until, as the modern (Holocene) era began around 12,000 years ago, only the eight bear species we know today remained on Earth.

Today's brown bears first existed in a geographically continuous population across Eurasia before crossing into North America. Initial studies concluded that the Laurentide and Cordilleran ice sheets limited the migrating bears' ranges to Alaska, the far north of Canada and a few island refuges, such as Admiralty, Baranof, Chichagof and Queen Charlotte, and that their range only extended further south – into southern Canada and the contiguous United States – after the ice receded, about 12,000 years ago. However, a recent fossil discovery made near Edmonton, Alberta, dating to before the last ice age, indicates that they almost certainly migrated south much earlier than first thought – at least 26,000 years ago.

Fossil evidence also suggests that polar bears (*Ursus maritimus*) evolved from ancestral brown bears living in northeastern Siberia around 300,000 years ago. In terms of evolution, a new species is formed over many millions of years after one or more groups within a population become isolated from the parent group, either by behavioural isolation (the development of distinct breeding behaviours, so that individuals from different groups may meet but do not mate) or geographic isolation (caused by physical land barriers that prevent contact).

Polar bears are believed to have evolved when a group of early brown bears became isolated on or near the pack ice. They then adapted to living

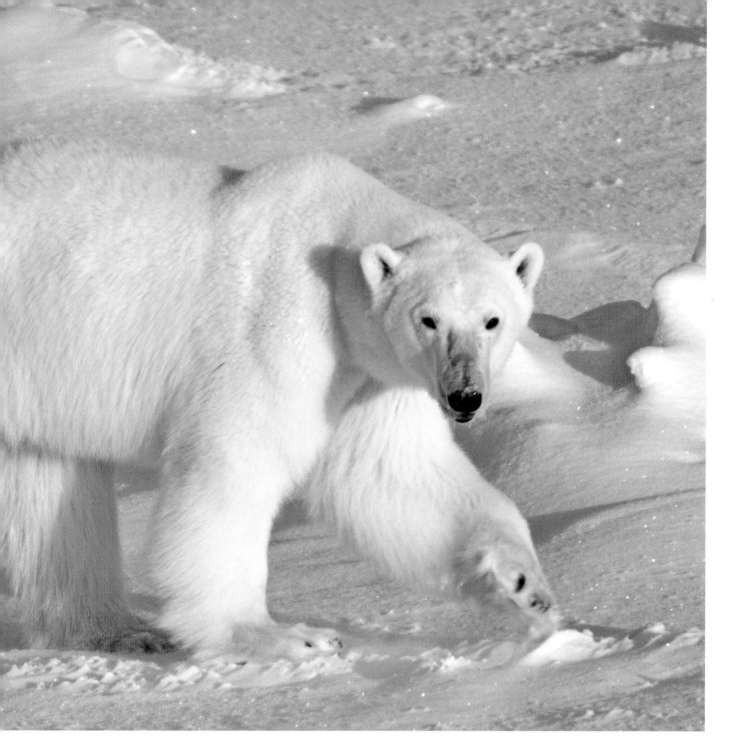

there. However, neither behavioural nor geographic isolation exists between the two species, which encounter each other where their territories overlap and have been known to breed. This observation also gives rise to an interesting theory about the future of polar bears, which are heavily threatened by current changes in Earth's climate. As Arctic ice recedes, it's possible that polar bears will be forced to head back south and eventually rejoin with brown bears – the beginning of the end of the polar bear as a distinct species?

A year in the life

A new year begins when bears wake from their winter sleep, emerging from their dens scrawny and starving...

SPRING, and adult males, lone females and females with older cubs quickly begin to roam their home range in search of food to replenish their dwindling energy supply. For some females, however, their own health isn't their only concern. While they slept, new cubs were born — cubs-of-the-year — totally dependent on their mother for food and security.

New mothers are sluggish, half their winter size, and so stay close to the den, often building day nests for resting. Their newborn cubs find release like uncoiled springs, full of energy and curiosity, playing joyfully in the snow, running, jumping and climbing (overleaf).

16

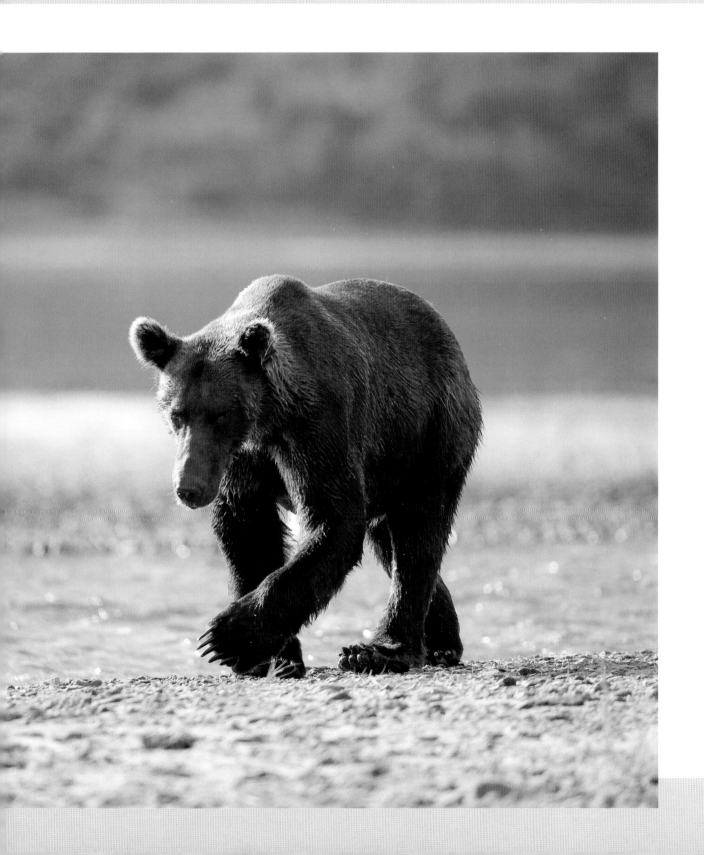

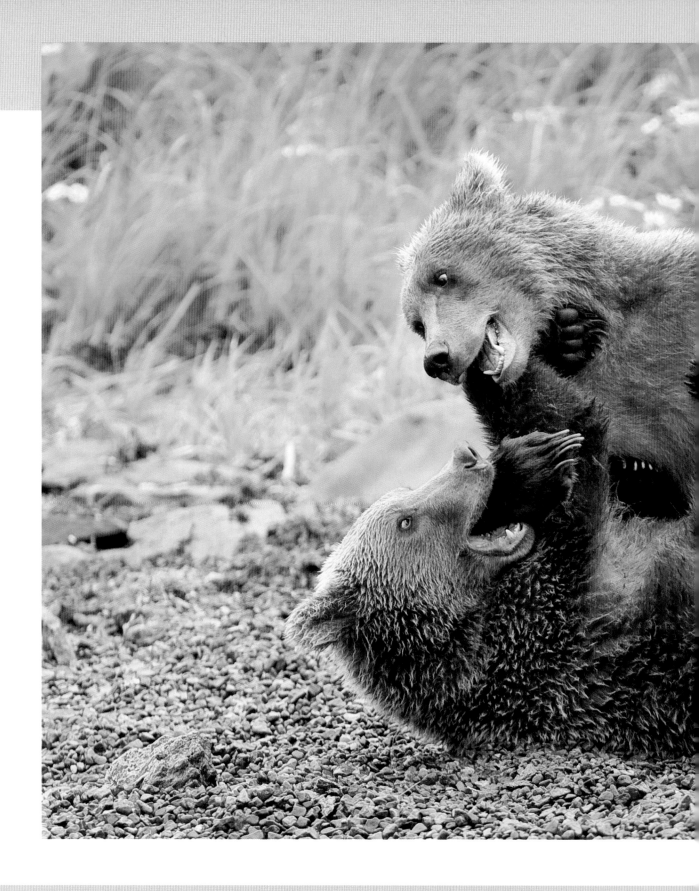

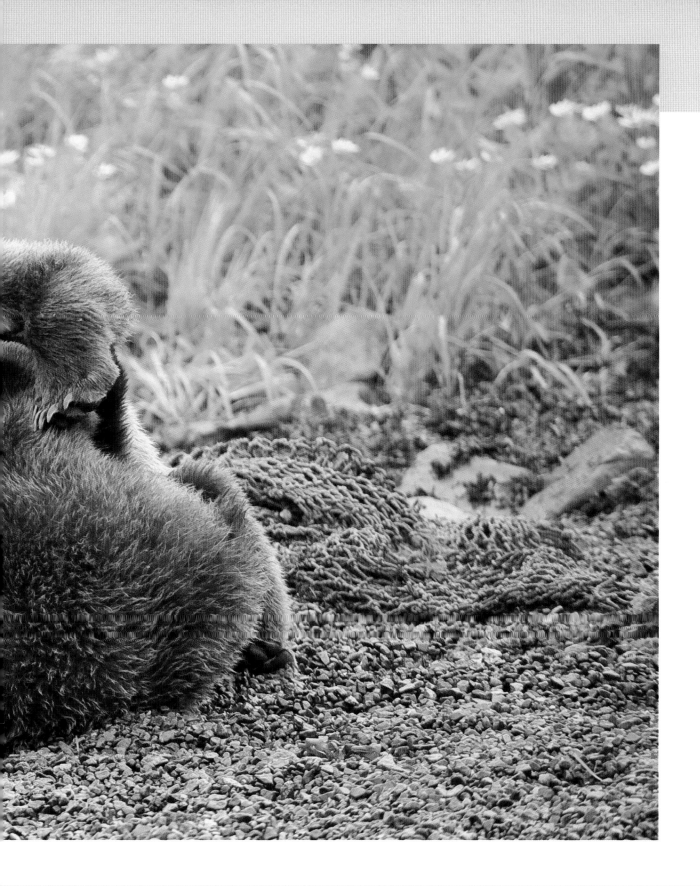

After regaining body weight, bears' minds turn to other things – namely sex. Mating rituals begin in late spring. Solitary by nature, bears avoid contact with one another for most of the year, so females leave scent trails to attract amorous males. Courtship lasts up to 15 days, as the couple get to know each other and gain each other's trust. Once bonded, they mate for several days, before separating and returning to their solitary lifestyle.

SUMMER has dawned and the bears spend the season feasting on whatever food they can find, ranging from large mammals, rodents and insects to berries, seeds and grasses.

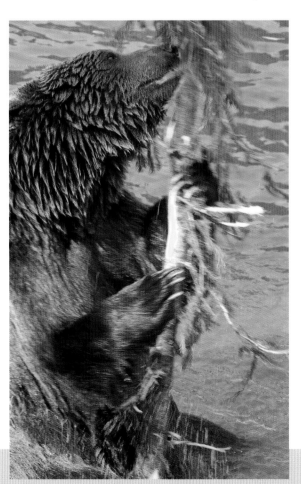

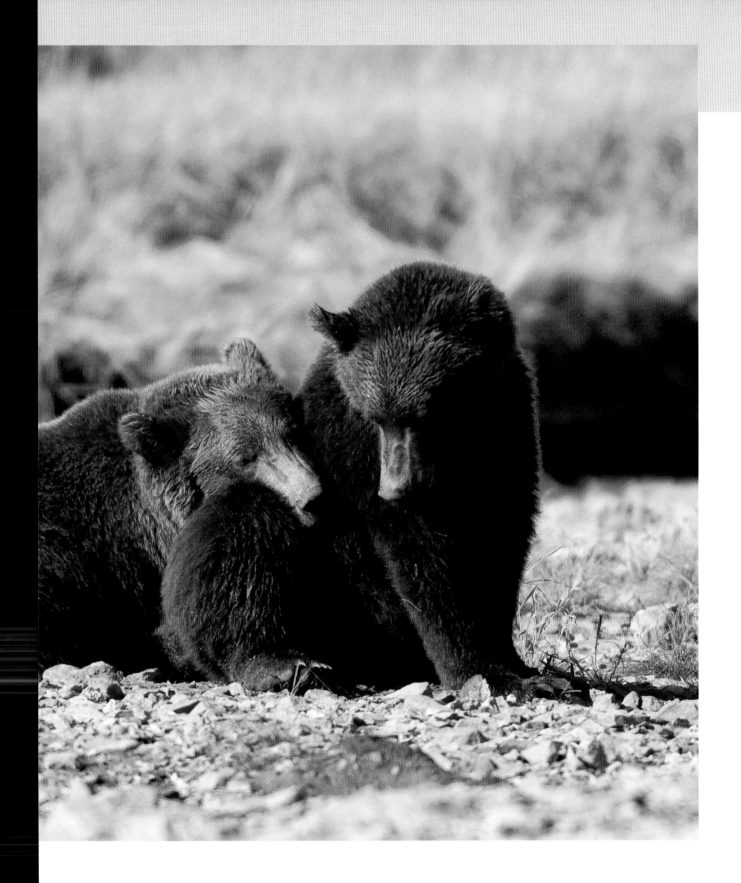

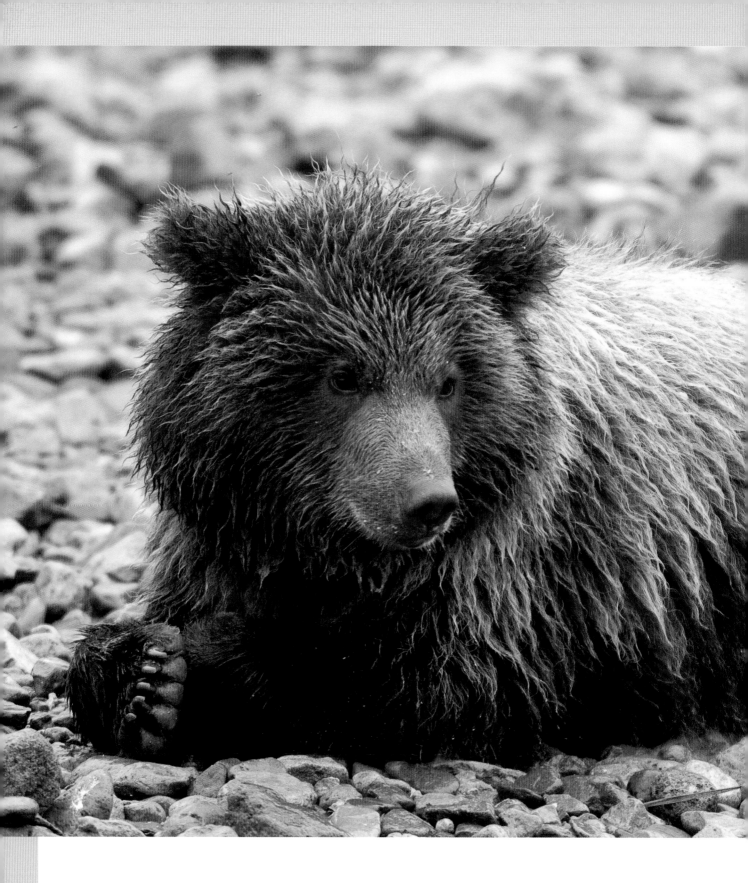

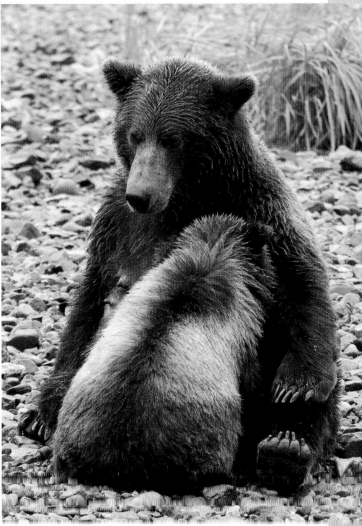

Away from predatory males, the new mothers have suckled their tiny cubs throughout spring. By mid-summer, on a diet of milk alone, cubs-of-the-year have grown to ten times their birth weight and are ready to forage for solid food.

For these youngsters, mortality rates are high (around half will perish through hunger or predation) and so they need to develop quickly and learn essential survival techniques if they are to see the year through.

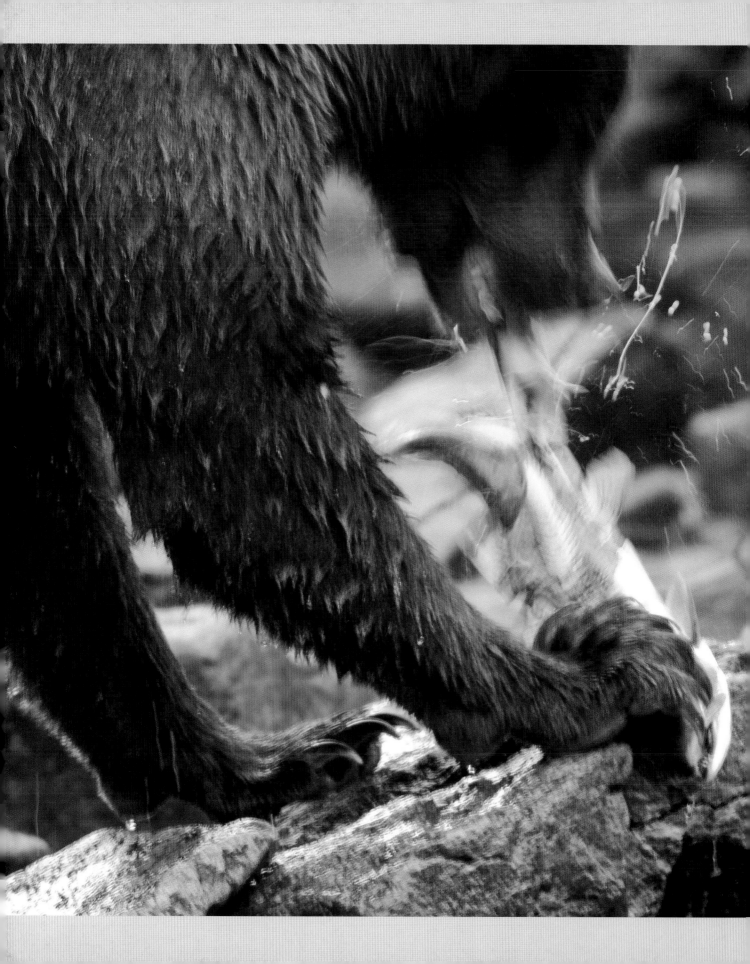

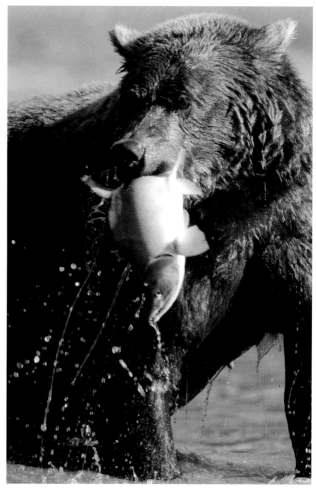

AUTUMN succeeds summer, and bears' physiology progresses into a state of hyperphagia — overeating. Their appetite is ravenous and it's essential they eat large quantities of nutritive, high-energy foods in order to accumulate the excess body fat that is crucial for surviving winter.

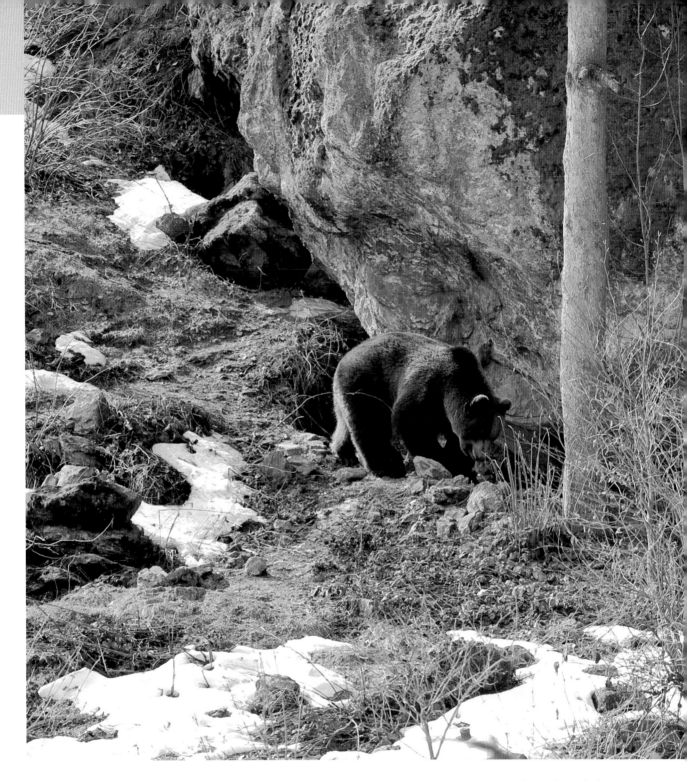

WINTER, and as the first snow falls, denning preparations begin. Creatures of habit, bears often return to favoured sites to dig their own dens, but are just as likely to make use of natural caves or crevices, or hollow logs and trees. Warm, cosy and fat with food, in their snug winter homes bears find protection from the elements and from danger. Now they will sleep, waking only if disturbed. And for healthy mothers gestation begins.

A few weeks later, while their mother sleeps, cubs are born in the den. Weighing less than a bag of sugar, they are blind, hairless and entirely defenceless. They snuggle against their mother for warmth and feed on her fat-rich milk.

After three weeks, they open their eyes onto the dark world inside the den, where they remain, growing fast, until it's time to emerge into the light and investigate their surroundings. Then a new year begins in the lives of bears.

Distribution

Despite continuing human development of their habitat and persecution by man, brown bears are one of the world's most widely distributed wild mammals. Bears' historic range included most of Europe and Asia, across to Alaska and down through Canada and the western United States as far south as Mexico. At one time they also inhabited northern Africa.

This historic range has shrunk considerably, particularly in Europe and North America, and, while the species remains relatively abundant in

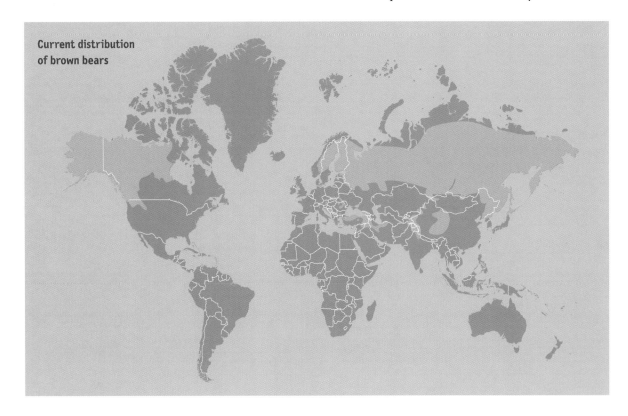

Current distribution of brown bears

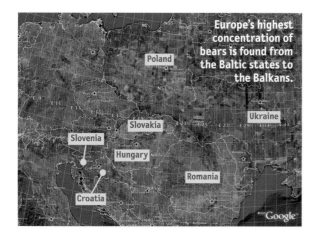

Europe's highest concentration of bears is found from the Baltic states to the Balkans.

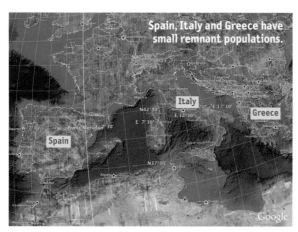

Spain, Italy and Greece have small remnant populations.

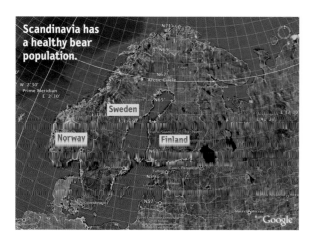

Scandinavia has a healthy bear population.

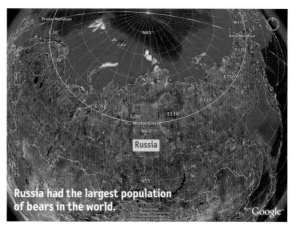

Russia had the largest population of bears in the world.

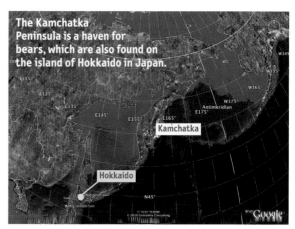

The Kamchatka Peninsula is a haven for bears, which are also found on the island of Hokkaido in Japan.

the northern parts of its distribution, the southern ranges are now highly fragmented.

In Europe, an estimated 14,000 individuals live in ten widely dispersed populations. The largest is found in eastern Europe, throughout the Carpathian mountain range, from southern Poland to Romania. There are also relatively healthy populations in the Balkan countries and in Scandinavia. Elsewhere in Europe, particularly western Europe, bears are either extinct or severely threatened.

Russia has the world's largest population of brown bears (c. 120,000), stretching from the Finnish border in the west to the Kamchatka Peninsula in the east. They're also found further south, inhabiting parts of the Middle East, eastern, southern and central Asia, and Japan.

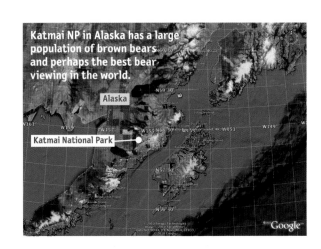

Katmai NP in Alaska has a large population of brown bears and perhaps the best bear viewing in the world.

Alaska

Katmai National Park

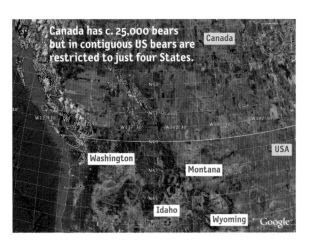

Canada has c. 25,000 bears but in contiguous US bears are restricted to just four States.

Canada

USA

Washington

Montana

Idaho

Wyoming

Brown bear populations in major geographic ranges

Region	Population	% of total pop.
Scandinavia	4,000	2.0
Western Europe	1,500	<1.0
Eastern Europe	8,500	4.3
Russia	120,000	60.4
Japan	2,000	1.0
Asia (excluding Russia and Japan)	5,000	2.5
Alaska (excluding Kodiak Island)	28,000	14.1
Kodiak, Afognak and Shukak islands	3,500	1.8
United States (excluding Alaska)	1,200	<1.0
Canada	25,000	12.6
Total	**198,700**	

Note: Statistical analysis of worldwide populations is problematical and accurate research is limited. Therefore the numbers quoted above must be regarded as estimates.

In North America, bears have disappeared from much of their southerly range. The largest populations are now found in Alaska and western Canada, although small populations have been identified in the Rocky Mountain states (Wyoming, Idaho and Montana), as well as in Washington State. Increasingly, as climate change affects ice levels in the Arctic region, brown bears are able to extend their range northwards, into northern Canada.

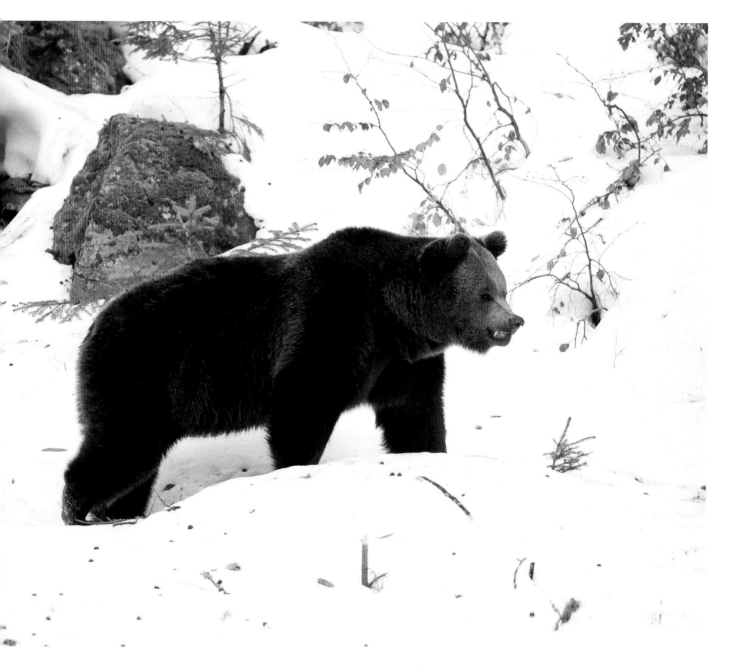

In some areas where bears have been eradicated, repopulation has been recorded. For example, in Europe, a few wandering bears crossed into Switzerland from Italy and into Lithuania from Latvia and Belarus. Currently, numbers are too small for these to be considered self-sustaining, resident populations. However, there is an encouraging precedent. In the 1920s Finland's bear population had reached an all-time low. It then resurged with

Above: Records show that bears have crossed into Switzerland from Italy within the very recent past. Repopulation of other regions where bears were once eradicated has also been recorded.

the immigration of Russian bears, which crossed the border in the east and dispersed to the southern and western parts of the country. Today, Finland has a population of around 800–900 bears.

31

Habitat

One reason for bears' global success is their ability to utilise wide-ranging habitats, from high mountains (up to 5,000 m/16,500 ft) to temperate coastal rainforest, dry Asian steppes and even Arctic tundra.

In Europe, the predominant habitats are boreal forests and the mountainous regions of the Carpathians and, to a lesser extent, the Alps. In southern Europe, bears live in the Cantabrian Mountains in Spain, particularly the beech-oak forests along the crest, and in the Pyrenees, along the border between Spain and France. Beech-oak forests are also a favoured habitat of Greece's 200 bears.

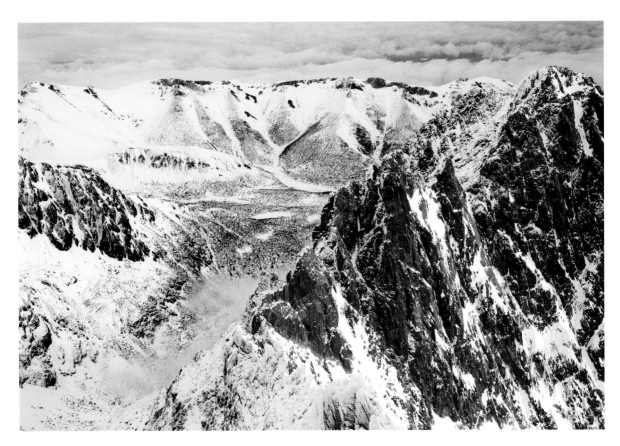

Above: The Tatra Mountains in Slovakia, home to a healthy population of European brown bears.

Opposite: Bears' preferred habitat varies widely, a favourite being boreal forests.

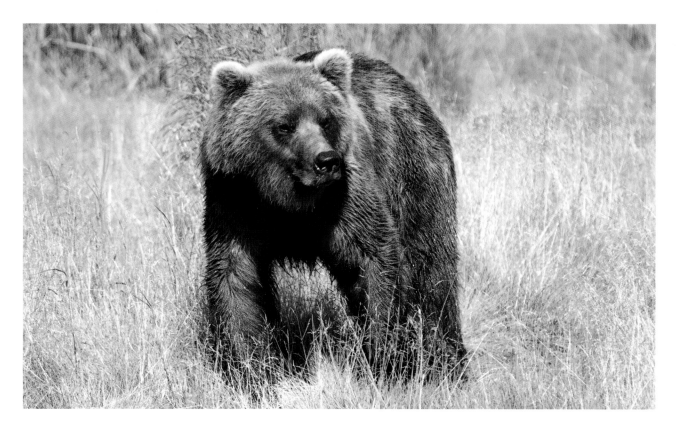

In North America, habitat use is defined by region. In the Rocky Mountains, bears follow the seasons. In spring, they descend from elevated dens to forage in low-elevation meadows and seek caribou calving areas. During summer, they occupy mixed shrubfields, grasslands and meadows, before going back up the mountains in autumn, to feed first on berries (at mid-elevations) and then on whitebark pine seeds (high elevations). Where humans are more numerous, bears seek the security of remote, mountainous forests.

Along the coast, low-elevation forests on and around riverbanks are favoured, mainly because of the two major food sources found here: salmon and berries. Thanks to the abundance of food, these areas are renowned for high concentrations of bears. Estuaries – sources of sedges and marine invertebrates – are also popular with coastal bears, particularly during spring, before the salmon run begins.

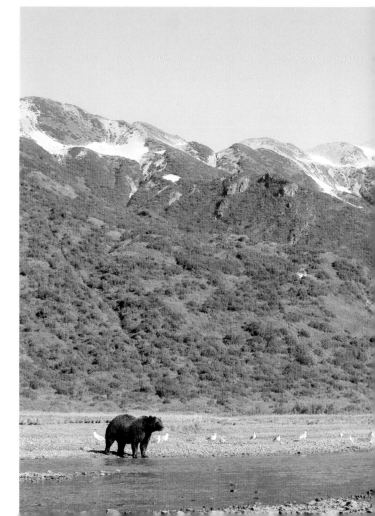

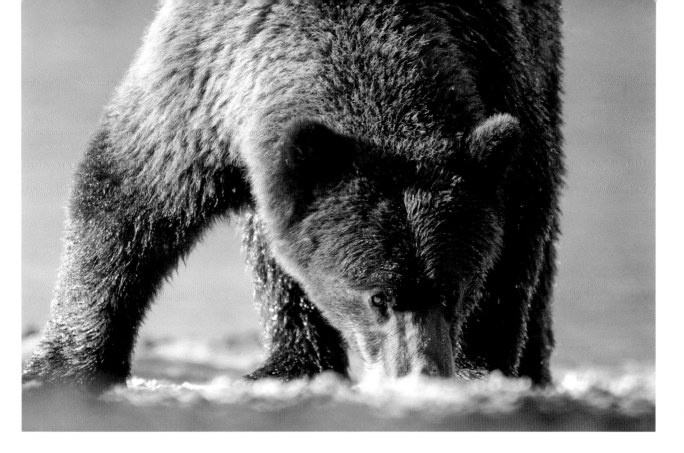

Above left: In spring bears like to forage in low-elevation meadows.

Above: Generalist feeders, bears have learned to make the best of many varied habitats.

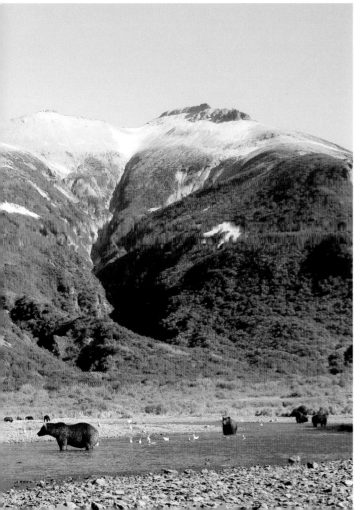

Left: Estuaries are a favourite habitat of coastal bears.

Further north, in the Arctic regions, bears rely heavily on vegetation as a staple food and so inhabit dry tundra, floodplains and tussock tundra. Caribou calving season – May and June – is an important time. Calves under a month old are particularly vulnerable to bears, who will chase them down, although the predators do best if the caribous' migration paths overlap the foothills where they den. As summer progresses, wet meadows, the eco-tones between wet meadows and dry tundra, and areas of late snowmelt are critical sources of food. Later, the bears' diet reverts to vegetation and small mammals found in dry tundra, riparian zones and wet sites.

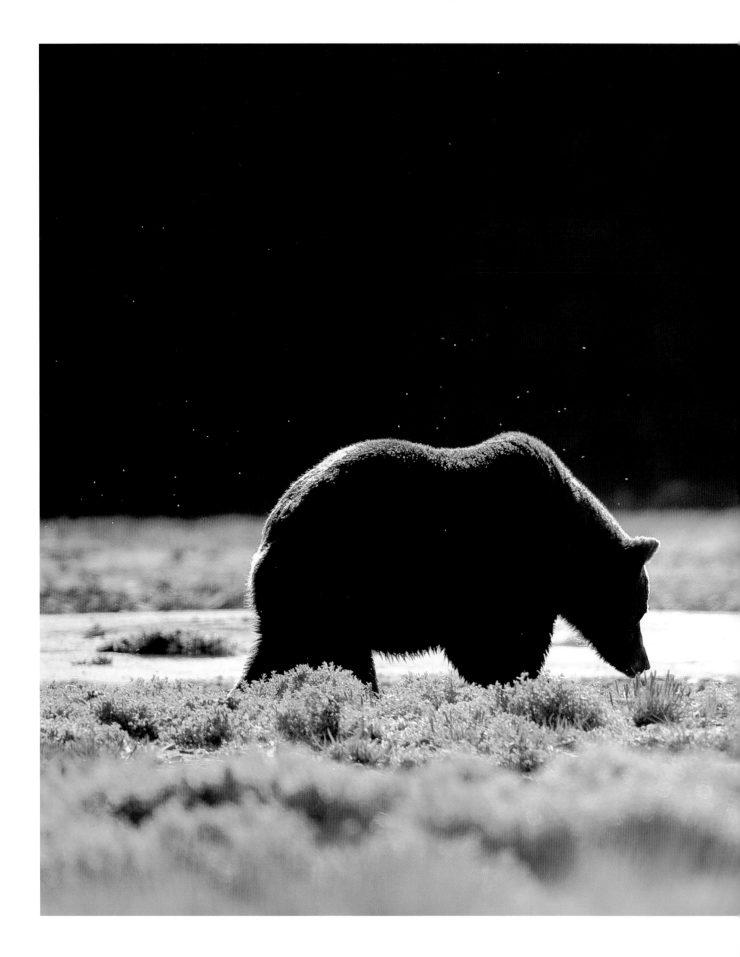

In Asia, habitat is similarly varied. Russia's large population of bears spreads throughout the country's vast tracts of virgin forest, such as the Taiga. Further east, along the Kamchatka Peninsula, bear habitat closely mimics that found on the opposite side of the Bering Strait, in Alaska. South and east of Russia's great forests, trees give way to the perennial grasses of the steppes, which provide habitat for bears ranging from Kazakhstan to northeast China.

In the southwest of the continent, the secluded forests of the Caucasus Mountains provide habitat for a small population of Syrian bears, while the grasslands of the Pamir Mountains (covering Tajikistan, Kyrgyzstan, Afghanistan, Pakistan and China) and the unique wild walnut and apple forests, and Schrenk's spruce forests of the Tien Shan Mountains that range between China, Pakistan, India, Kazakhstan, Kyrgyzstan and Uzbekistan are home to the locally named 'white-clawed' brown bear.

Left: Russia's bears are spread throughout the country's vast forests and along the Kamchatka Peninsula.

Taxonomy

There is much debate and little agreement on the classification of brown bears. Several subspecies are widely discussed (see table on page 49), but the International Union for Conservation of Nature (IUCN), which produces the definitive international standard for species extinction risk – commonly known as the Red List – recognises only the single classification *Ursus arctos*. Of all the brown bears, the Kodiak (*Ursus arctos middendorffi*) and Hokkaido (*Ursus arctos yesoensis*) variants are the closest to being universally recognised subspecies due to their geographic and genetic isolation.

Right: The largest recorded bear was found on Kodiak Island, Alaska, weighing over 1,100 kg (2,500 lb).

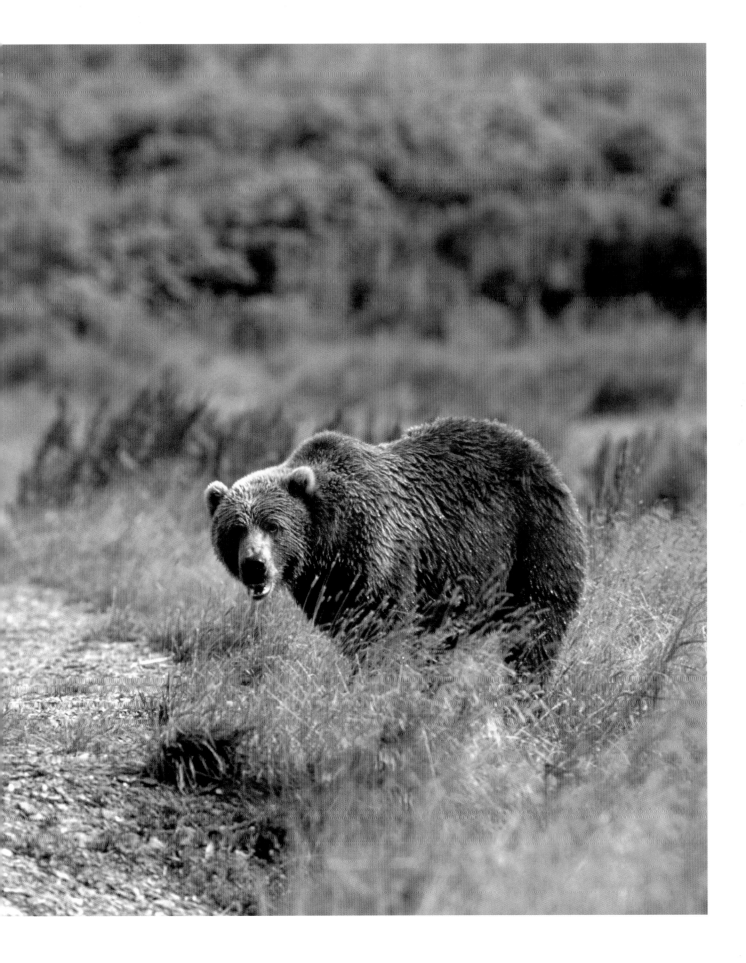

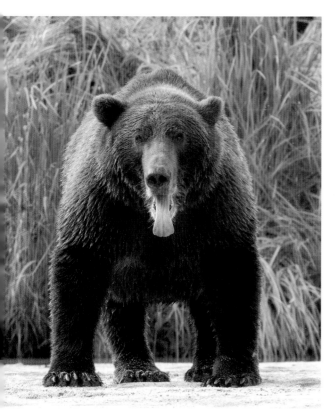

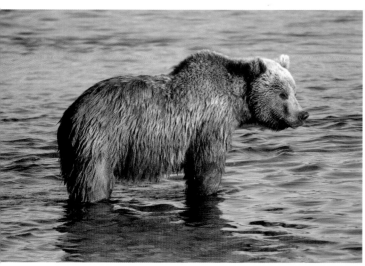

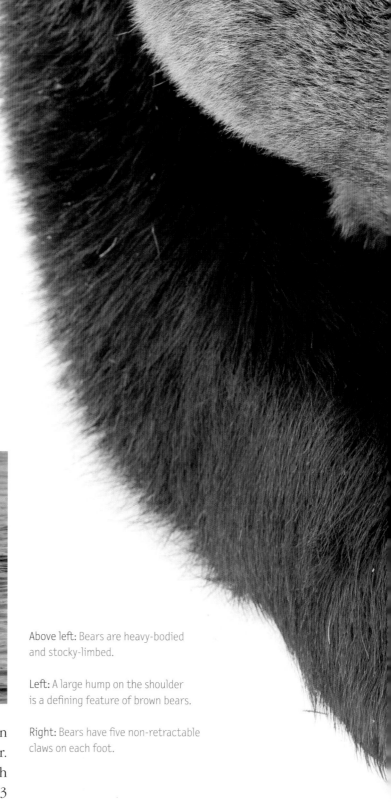

Above left: Bears are heavy-bodied and stocky-limbed.

Left: A large hump on the shoulder is a defining feature of brown bears.

Right: Bears have five non-retractable claws on each foot.

Despite their wide geographic dispersion brown bears the world over are largely similar. They are heavy-bodied and stocky-limbed with five non-retractable claws around 5–6 cm (2–2.3 in) long on each foot. A defining feature is the large hump on the shoulder, a mass of muscle that powers the forelimbs.

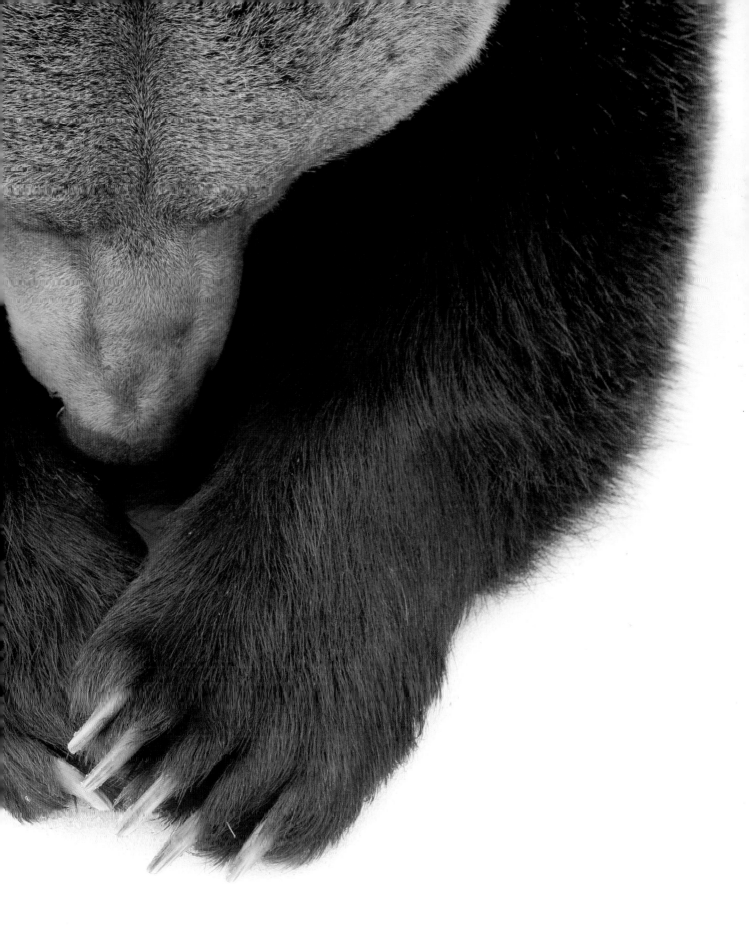

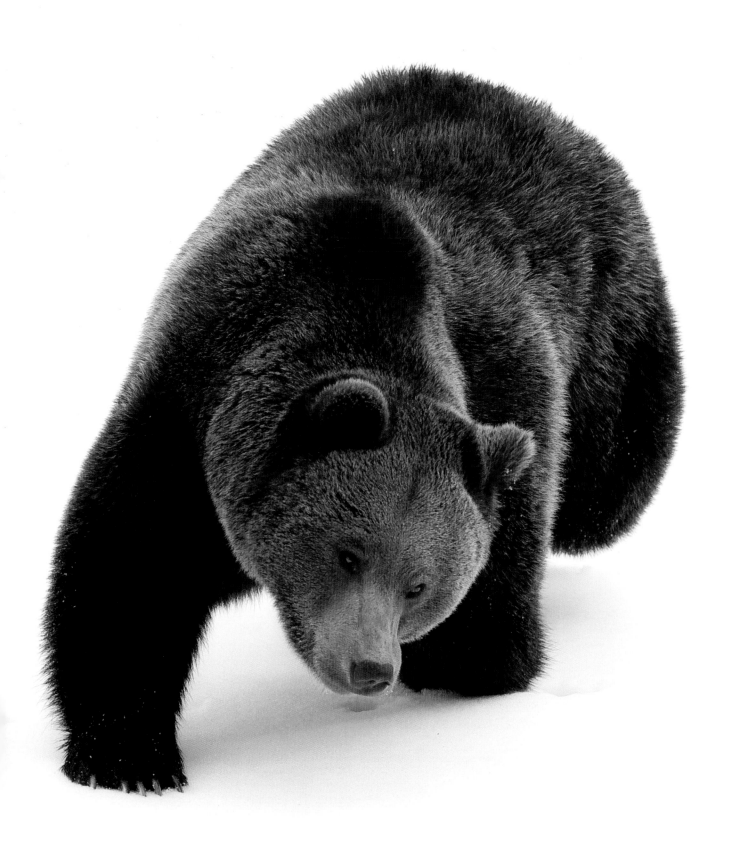

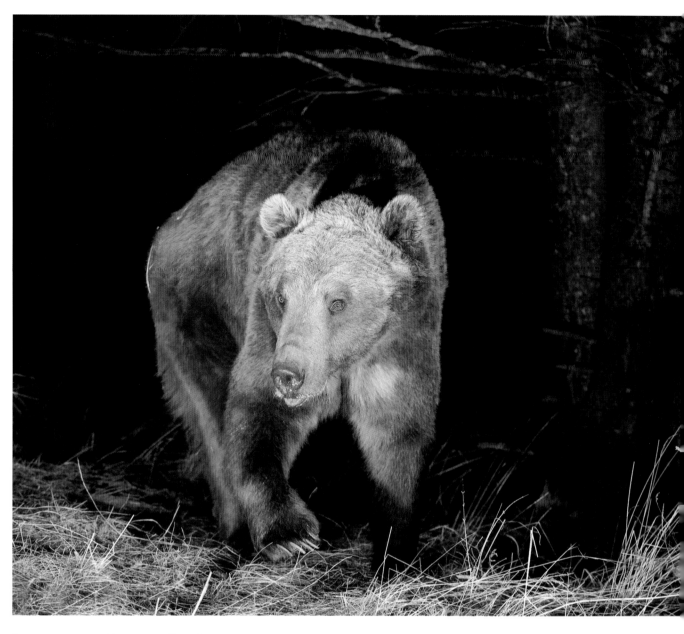

Opposite: Bears are able to move efficiently through snow.

Above: Grizzly bears are most active at night.

The main biological variation between groups is size. On average, males weigh between 135–390 kg (300–860 lb) with females around 30–40 per cent smaller at 95–205 kg (210–450 lb). In North America, inland bears, often referred to as grizzlies (*Ursus arctos horribilis*), are generally smaller than their coastal cousins, primarily due to variations in diet. The same applies in Russia. The smallest brown bears (weighing as little as 90 kg/200 lb) are found in parts of Europe, while the undisputed king is the Kodiak bear of Alaska, normally weighing up to 680 kg (1,500 lb). The heaviest recorded Kodiak tipped the scales at over 1,150 kg (2,530 lb) – the weight of a small car.

Average shoulder height is 1 m (3.25 ft). When standing on their hind legs, bears typically reach 2 m (6.5 ft), although some males stand as high as 2.5 m (8 ft) and some Kodiaks have been recorded at over 3 m (10 ft). In length, on average bears vary between 1.7 and 2.8 m (5.5 and 9 ft).

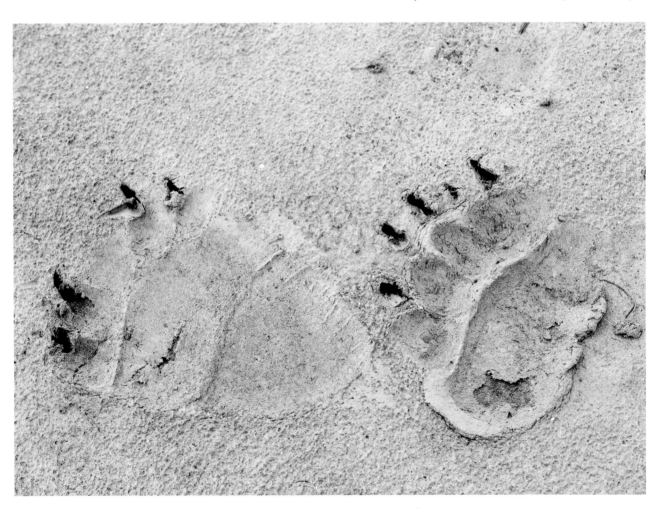

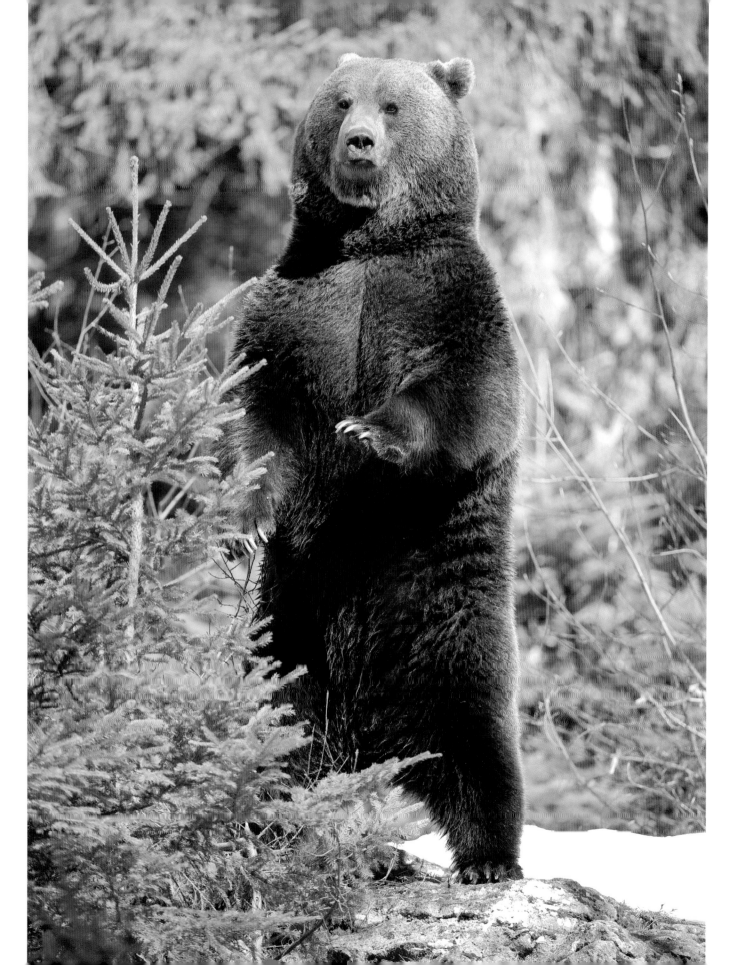

All brown bears have proportionally large, heavy, concave skulls, the dimensions of which vary between regional groups (for example, grizzlies' skulls have flatter profiles than either coastal or European groups). They have powerful jaws and strong teeth. The incisors and canine teeth are large, the lower ones being curved. The first three molars of the upper jaw are underdeveloped and single-crowned with one root. The second upper molar is smaller and usually absent in adults, having been lost at an early age, along with the first three molars of the lower jaw.

Right: The head is proportionally large but the eyes are small.

Below: Bears have powerful jaws and strong teeth.

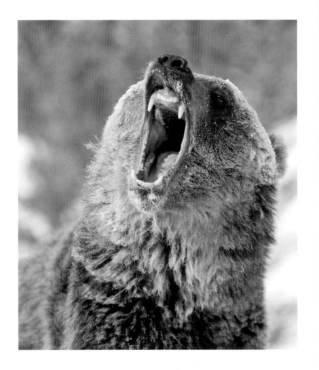

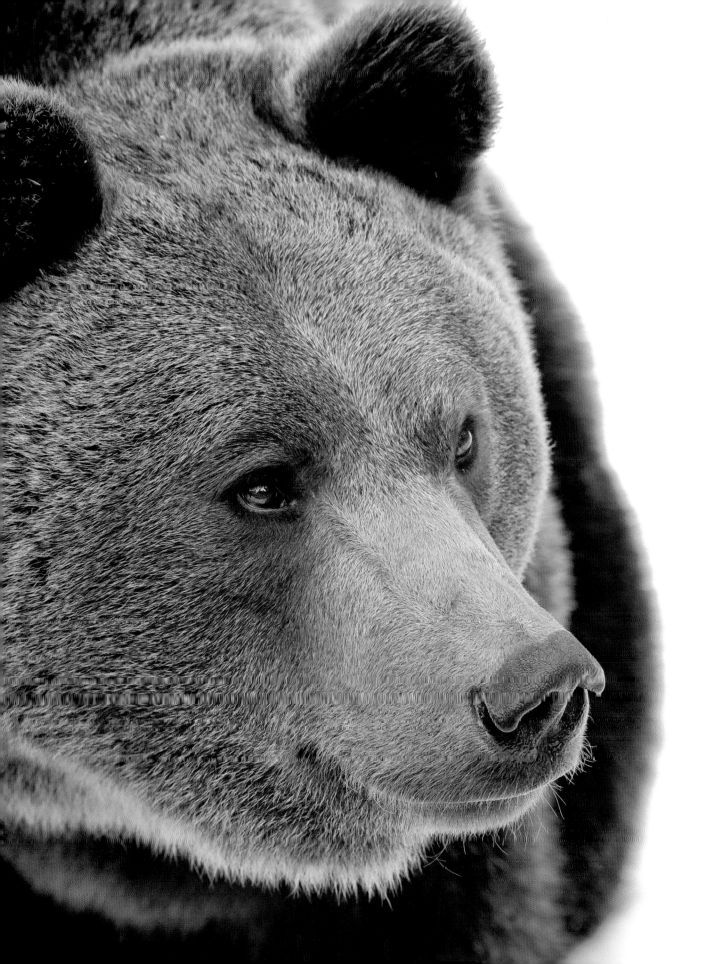

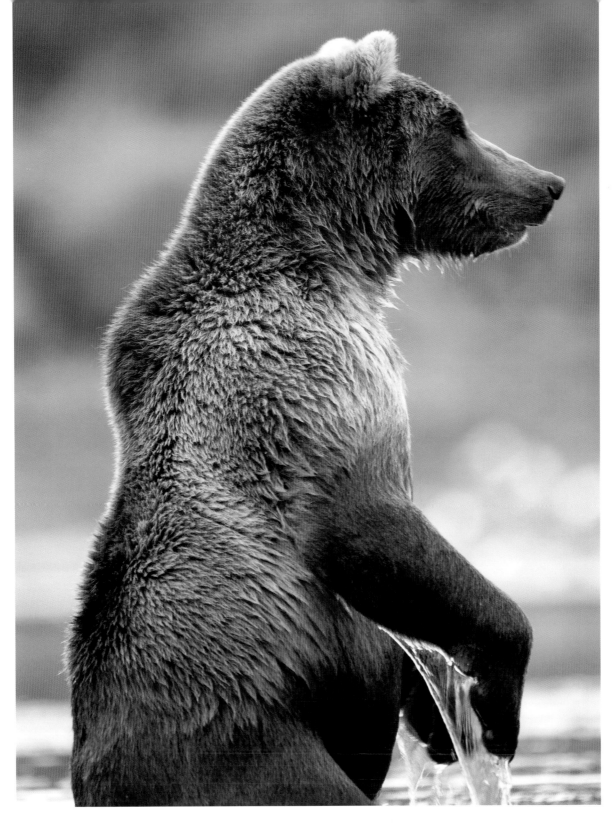

Above: The long snout aids bears' primary sense – smell.

Opposite: Pelage varies widely in colour from nearly white to blonde, brown, cinnamon and almost black.

Bears have two layers of fur to help them stay warm in winter. During the summer, the shaggy outer coat is shed to leave just the thinner undercoat. Despite their name, brown bears' pelage varies in colour from blonde through cinnamon to very dark brown and almost black. The greyish, grizzled tip of the fur of inland bears is the reason for the name 'grizzly'.

Informal classification of brown bear

There are no formally accepted subspecies of brown bear (*Ursus arctos*); however, the following classifications are widely used:

Latin name	Common name	Location
Ursus arctos arctos	Brown bear	Europe, west & central Asia & coastal North America
Ursus arctos horribilis	Grizzly bear	Inland North America
Ursus arctos beringianus	Kamchatka bear	Eastern Russia
Ursus arctos middendorffi	Kodiak bear	Kodiak, Afognak and Shuyak islands
Ursus arctos syriacus	Syrian bear	Southwest Asia
Ursus arctos isabellinus	Himalayan bear	South Asia
Ursus arctos gobiensis	Gobi bear	Central Asia
Ursus arctos lasiotus	Ussuri or Amur bear	Southeast Russia and China
Ursus arctos yesoensis	Hokkaido bear	Japan
Ursus arctos pruinosus	Tibetan blue bear	China and Tibet

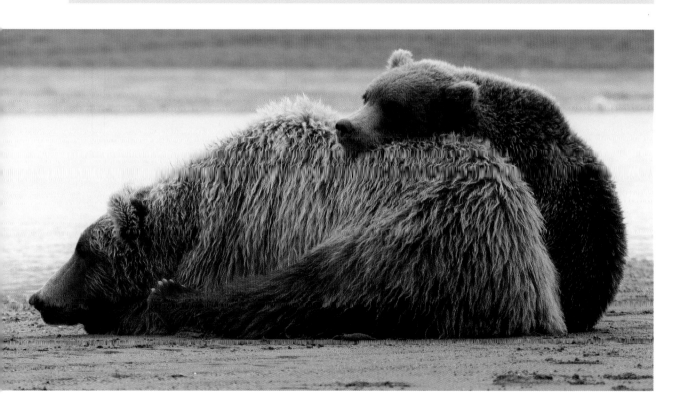

Behaviour

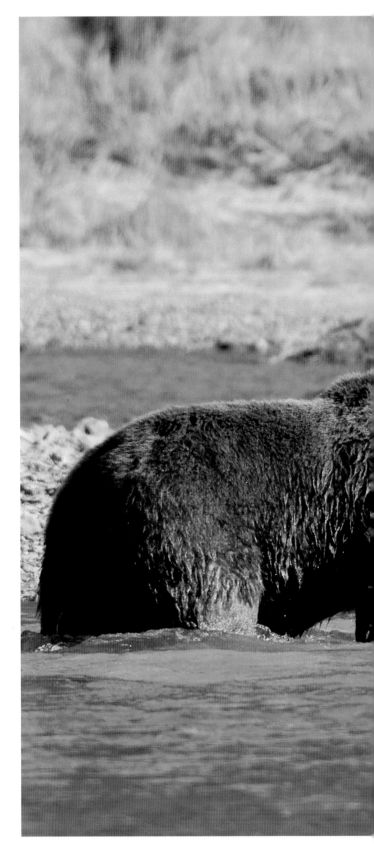

Some people believe bears are unpredictable. I beg to differ. We may not understand why a particular bear behaves in a specific way, but that's not the same as an animal behaving randomly. As with all mammals, bear behaviour is governed by a combination of genetic programming and social and environmental factors.

Bears are, on the whole, solitary animals. However, given that a bear's home range may extend up to 1,300 km²/510 sq. miles (775 km²/300 sq. miles for females), encounters are not uncommon. When bears meet, how they react depends largely on where they live. Interior bears (i.e. grizzlies) are more territorial and aggressive. However, in coastal areas, where food is plentiful, I've seen up to 50 bears sharing an area of ground no more than 1–2 km² (0.4–0.8 sq. miles).

Avoidance behaviour

Most predators prefer to avoid confrontation with others of their own kind, as the consequences are often fatal. Bear encounters typically result in aggressive displays that appear and sound more ferocious than they are: they enable the competing parties to size each other up and gauge each other's strength. Having witnessed many such displays, one could easily gain the impression that they were well-choreographed performances.

Right: An aggressive display is performed like a well-choreographed routine.

50

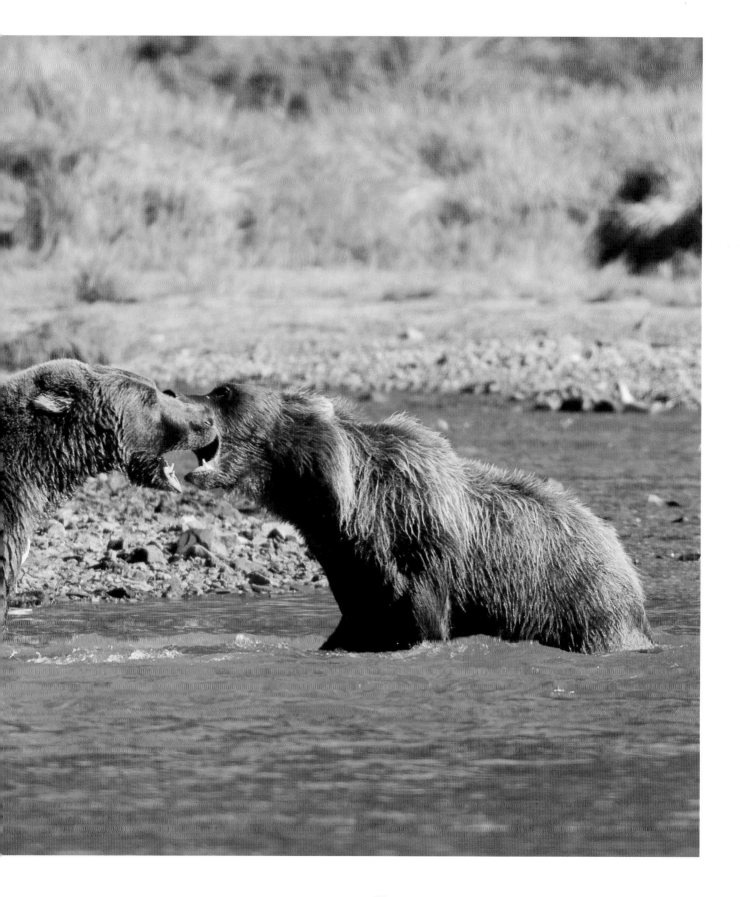

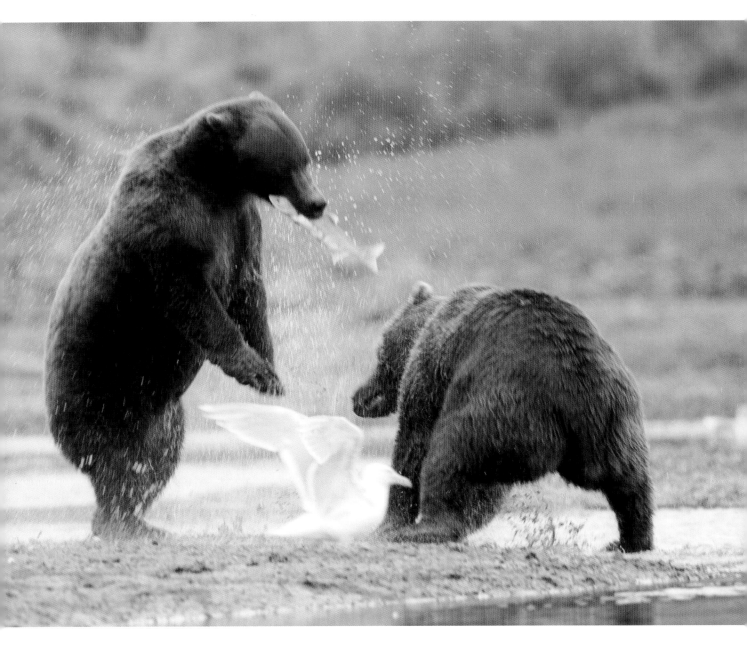

Aggressive displays are common when there are congregations of bears (such as during the annual salmon run) and are used to establish temporary dominance hierarchies, needed to maintain a level of control when the bears group. Typically these encounters end in the weaker of the two combatants backing down, showing suitably submissive behaviour (turning the head away, averting the eyes and exposing the neck). In most cases the dominant bear will allow the vanquished to escape unharmed. Females with cubs are generally more aggressive and will defend their offspring vigorously and forcefully, even against the much larger and stronger males.

When two equally dominant males fight, unless one backs down, a ferocious battle ensues. The combatants will use their teeth, claws and forearms to attack the head and neck, and injuries are often horrific and sometimes fatal.

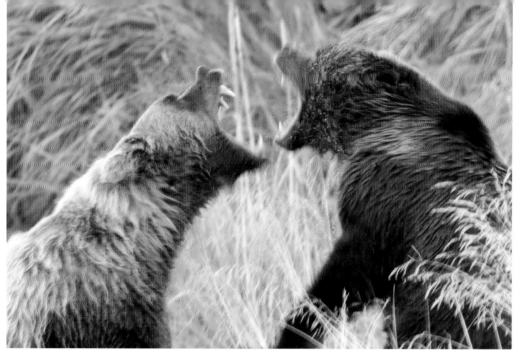

Opposite: Aggressive displays are more common where bears congregate in large numbers.

Left: Female bears protect their cubs vigorously.

Below: Wounds can be horrific but are rarely life-threatening, although fatalities do occur.

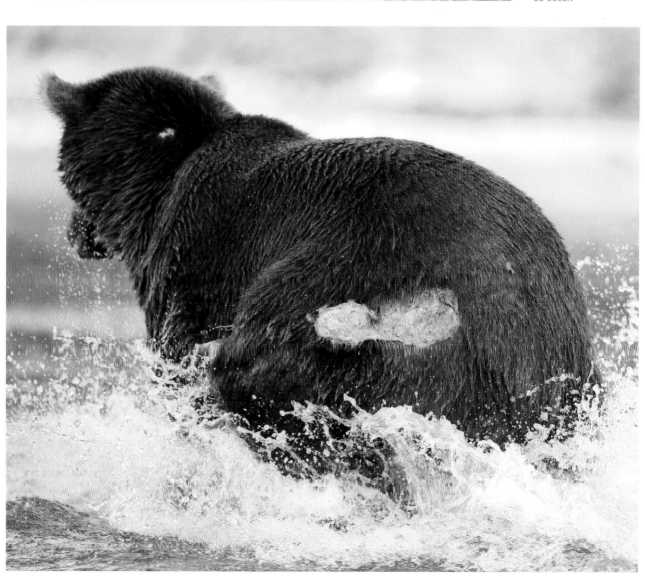

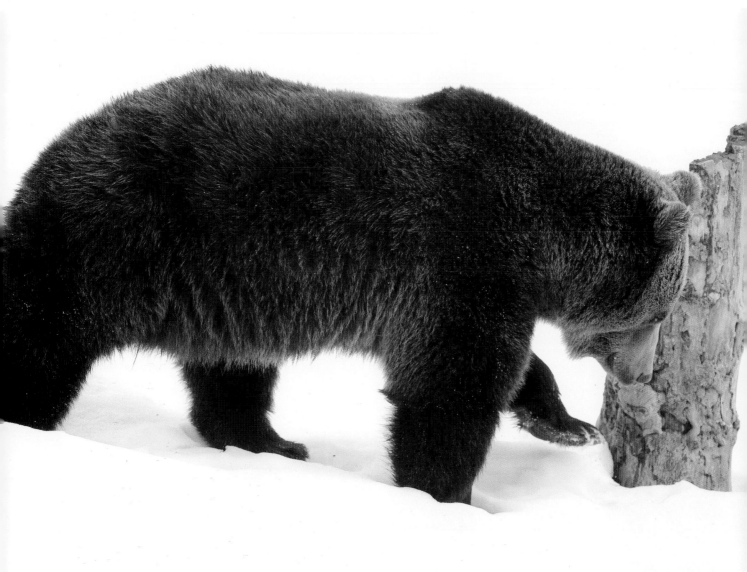

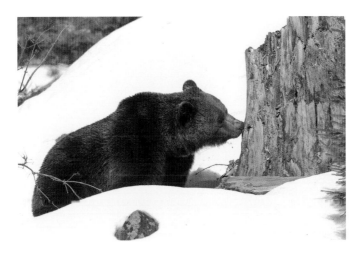

Above: Scent-marking is a form of avoidance behaviour.

Right: Trees are used as notice boards.

Far right: Scratch marks on a tree.

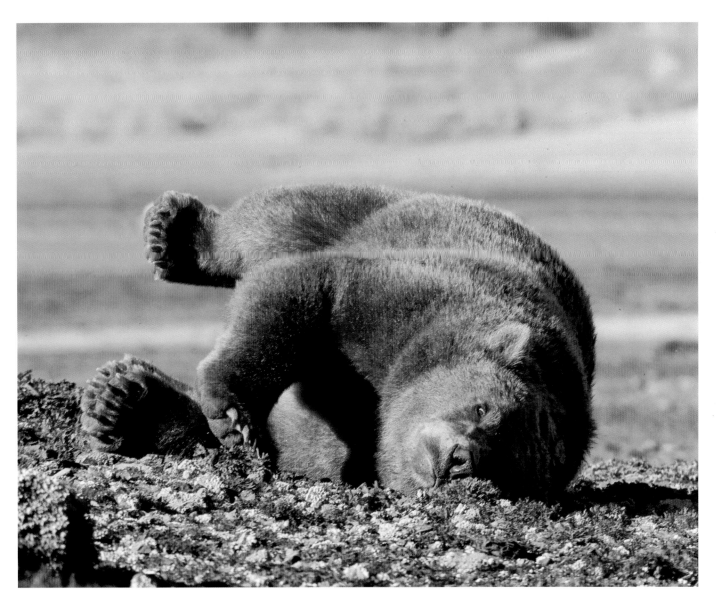

Above. Scent marking is another distinctive behaviour of bears.

Left: Bears will stand on their hind legs to sniff the air for other bears.

A common avoidance tactic, particularly in forested areas, is scent-marking. Bears tend to stick to well-trodden, established trails. Along these trails will be 'notice boards' – typically trees that bears rub, bite and claw in order to leave a message for others in the area. Passers-by will sniff scent trees to discover which other bears are around.

In more open ground, such as the Arctic tundra, scent-marking trees are less common, so bears use their highly adapted sense of smell to trace other bears. Often they will stand on their hind legs, sniffing the air.

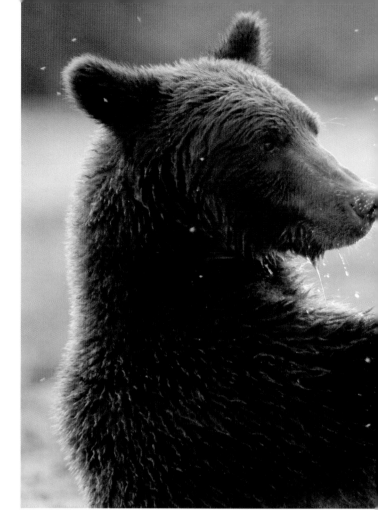

Cub killing

A well-documented behaviour associated with brown bears is cub killing. Little is understood about the reasons for this seemingly species-detrimental behaviour. Some biologists believe it's related to the predatory bear's desire to pass on his genes, as losing her cubs will bring a female into oestrus more quickly and enable the male to mate. Another theory suggests that it is driven by hunger, particularly since the victim is often eaten. There is probably an element of truth in both these theories. However, I have also witnessed a dominant bear killing a cub outside of the mating season, in an area where food was plentiful. In this instance, neither theory stands. It's likely that a combination of factors drives this behaviour, including genetic advantage and hunger, as well as individual differences in aggressiveness.

Top: Bears are generalist feeders and eat a varied diet.

Above: Berries make up a large portion of a bear's diet.

Opposite: Strong forearms and dextrous claws enable bears to upturn trees and rocks looking for grubs and larvae.

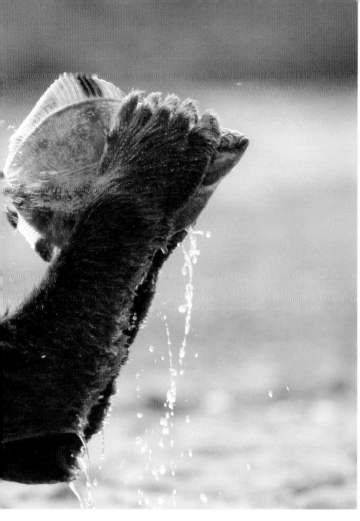

Feeding and predation

Although brown bears are categorised as carnivores and show some cannibalistic tendencies, they are typically generalists, relying more on vegetation than on meat for their survival. Their dietary intake relates directly to their environment and the season. In spring, immediately after the winter sleep, bears forage for the carrion of animals that perished during the winter, as well as for early spring vegetation, such as grasses, sedges and mosses. In the summer and early autumn they gorge on protein-rich and fat-rich foods, including berries (especially huckleberries), fruits, nuts, bulbs and tubers.

Regardless of the season, they use their claws and strong foreleg muscles to tear into logs and upturn rocks and small boulders, devouring the grubs and larvae beneath. They also dig into the burrows of small mammals, such as mice, ground squirrels and marmots.

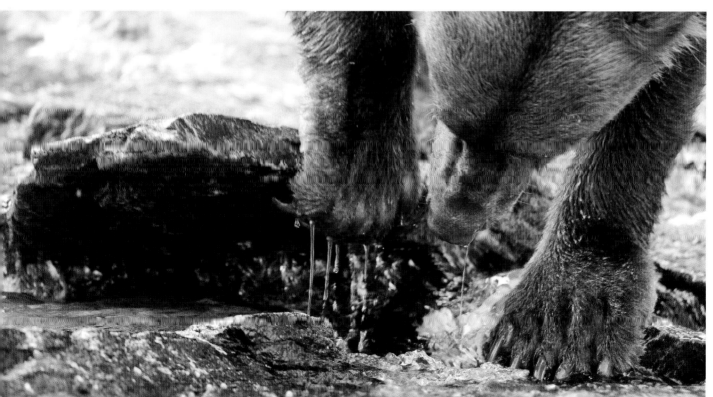

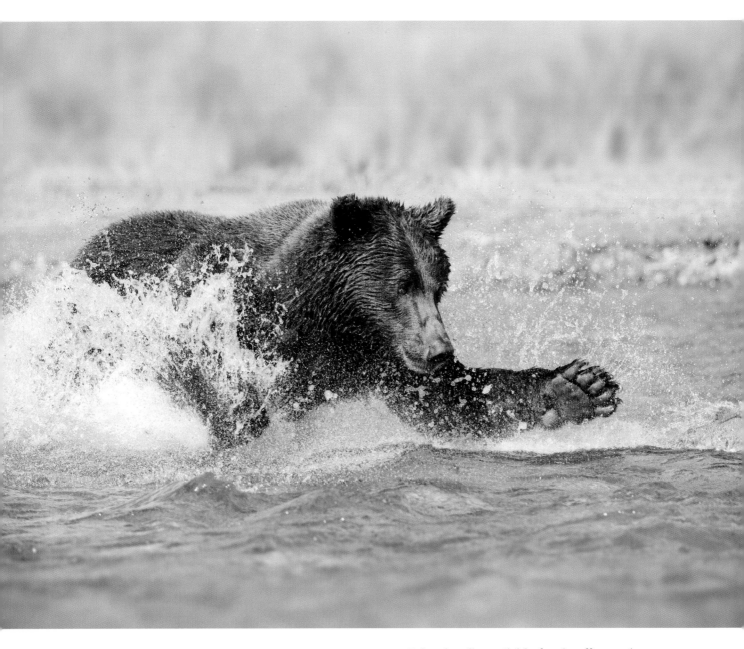

Above: Chasing a salmon in Katmai National Park, Alaska.

Other locally available foodstuffs supplement generic fare. For example, coastal brown bears in Alaska and Kamchatka consume large quantities of salmon during the annual migration known as the 'salmon run', when Pacific Ocean salmon make the long and perilous journey back to their spawning grounds in the rivers.

Individual bears have learned and developed their own fishing techniques for catching migrating salmon. Some 'snorkel' – head semi-

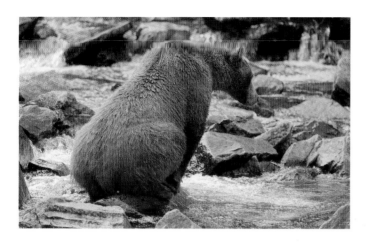

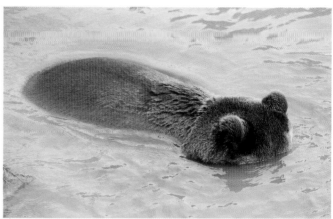

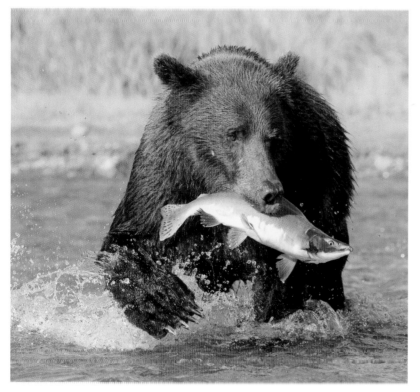

submerged before snapping up a juicy morsel. Others – typically the younger, less experienced animals – chase the salmon in a largely fruitless pursuit. Older and wiser bears sit and wait for an unsuspecting fish to pass them by, snatching it up with swift and accurate claws. Brooks Falls, in Katmai National Park, is famous for its bears, which sit at the top of a 3 m (10 ft) waterfall, simply waiting for an unlucky salmon to leap into their gaping jaws.

Clockwise from top left: Experienced bears conserve their energy and will sit and wait for passing salmon.

'Snorkelling' is a favoured fishing technique for some bears.

Scat shows that this bear had been feeding mainly on grasses...

...while berries formed the major recent food source for another.

Salmon make up a large part of the diet of coastal brown bears.

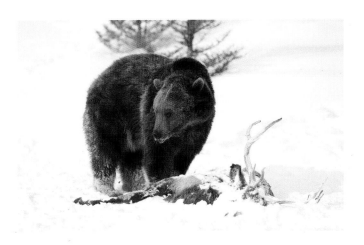

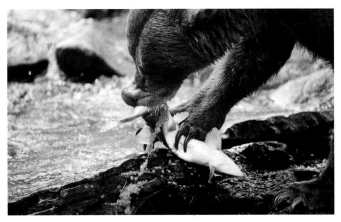

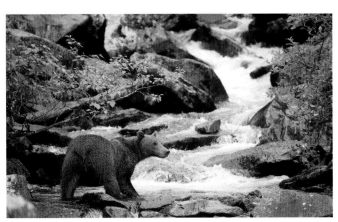

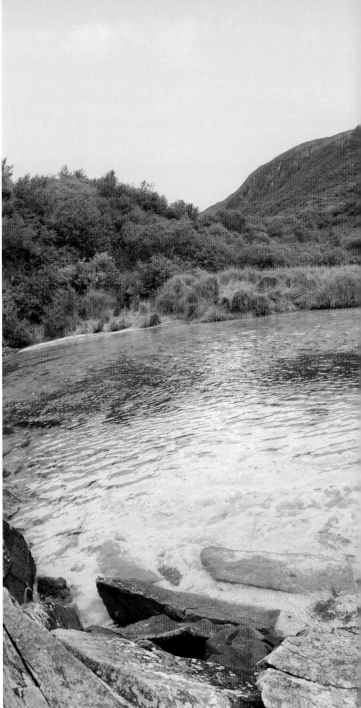

Main photo: A female coastal bear wanders along the edge of a salmon-rich pool in Katmai National Park.

Above from top: Carrion forms an important part of a bear's diet after the winter sleep.

Nutritionally rich salmon roe is preferred to the meat.

Waterfalls are popular fishing spots.

In Yellowstone National Park, Wyoming, bears fish for spawning trout and, in August, climb above the treeline to feast on calorie-rich moths, up to 40,000 per day. Bears in Glacier National Park, Montana, follow wolf packs to remote regions, scavenging meals of deer and elk, while the Kodiak bear, spoiled by an abundant and readily

available supply of large prey species, is far more carnivorous than its smaller cousins.

Although bears are typically unfussy eaters, when food is plentiful they will pick and choose. For example, watching bears in Katmai National Park, I have seen adults consciously discard a male salmon uneaten in preference for a female fish.

Having caught a female, the bear holds it down with one paw and, with the other, squeezes out the roe inside. It will then discard the fish, again uneaten, to concentrate on the eggs. Similarly, bears will throw away the salmon meat for which you and I pay a premium at the fishmonger's, consuming instead the skin and brains.

The winter sleep (hibernation)

As winter arrives bears begin to den. Evidence suggests that site choice isn't random. Bears seem to prefer an elevated position (2,000–2,500m/ 6,500–8,200 ft) on a slope with an angle around 30°. It's believed this gives the den a sturdy, solid roof of soil or rock and is sufficiently shallow for snow to fully cover the entrance, providing protection and insulation.

To create the den, bears shovel huge quantities of earth and rock with their forearms, showering the ground below with an avalanche of debris. A typical den is dug horizontally into the slope and has an entrance about 75 cm (30 in) wide by 55 cm (22 in) high. A short corridor leads to a snug chamber, just large enough for the bear to curl into (around 1–1.3 m/3.3–3.7 ft).

Once inside the den, bears sleep. There is some debate about whether this sleep constitutes true hibernation: bears remain in a continuously dormant state for up to seven months, whereas true hibernating mammals wake periodically in order to feed. A bear's body temperature remains unchanged (atypical in hibernating mammals). However, heart rate drops from 40–50 beats per minute to around ten, and metabolic rate reduces to about 68 per cent of normal.

The huge fat reserves built up since spring keep the bears alive. If the body has insufficient fat to draw on, it will use proteins to produce energy, endangering the animal's survival. During hibernation, bears lose around a quarter of their body weight. Fat, protein and bone are metabolised and the metabolised protein and bone are recycled to keep muscle and bone mass constant.

It is also during the winter sleep that females give birth to cubs.

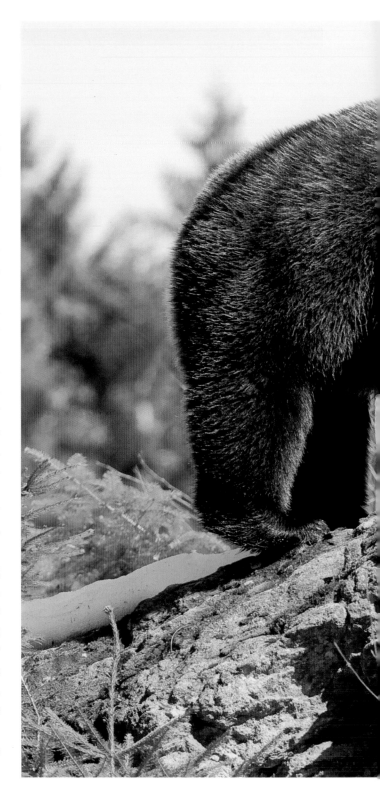

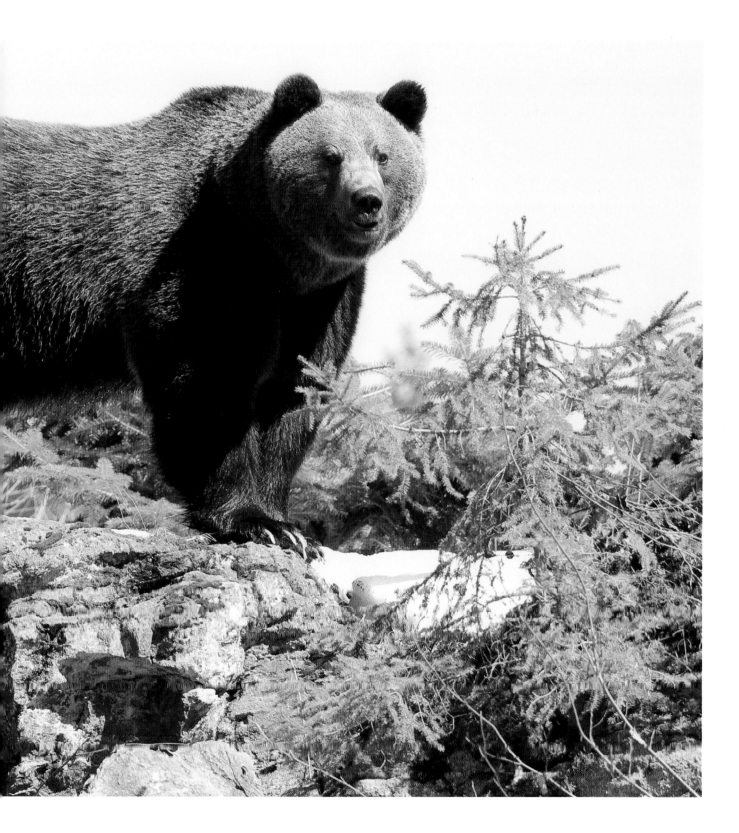

Above: Den sites are seldom chosen at random. A typical den is built in an elevated position.

Reproduction

Bears reach sexual maturity at around four-and-a-half to seven years old, although males of this age are too small to compete with larger males, so become sexually active later (8–10 years). The mating season begins in late spring/early summer (May–June). Because bears are solitary animals widely dispersed, females leave scent trails to attract prospective mates. When a male picks up the scent trail, he follows it until they meet.

Courtship usually lasts up to 15 days and is all about bravado for the boys and playing hard to get for the girls. At first, the female is unreceptive and the male wary. She will charge her suitor, pawing and biting him to test his strength and suitability. As they become acquainted, they begin to nuzzle and lick each other. At the end of the courtship, the female may still reject the male. If she accepts him, they bond for several days.

Right: After a successful courtship, bears generally pair for the season.

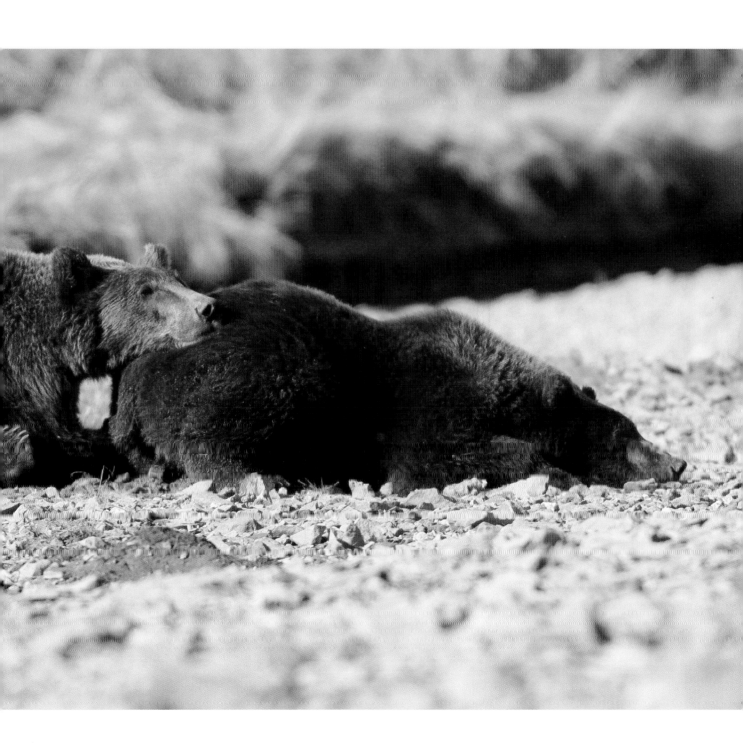

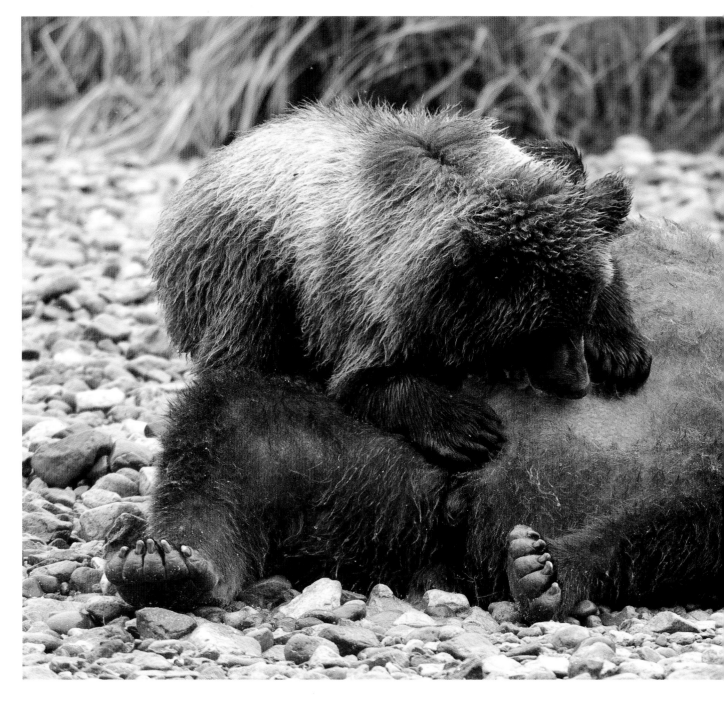

Above: A cub suckles milk from its laid-back mother.

As with most animals, including humans, mating is a competitive game for bears. In some areas, researchers have recorded unusual mating rituals aimed at limiting competition. For example, in Banff and Waterton Lakes National Parks in Canada, male grizzlies have been seen herding females up mountains to isolate them.

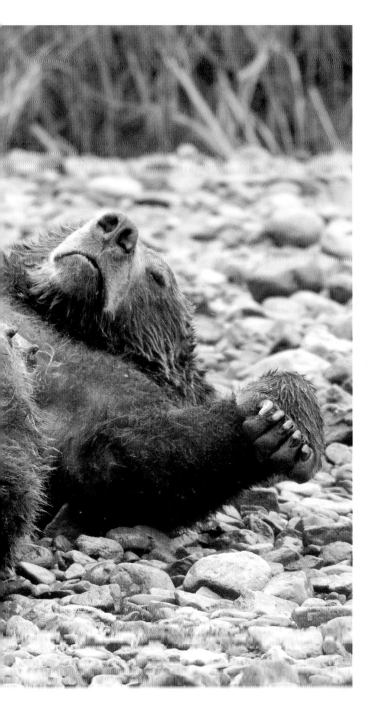

meadow where a paired couple were in the throes of mating. The copulating male bear took exception to the intrusion and in an angry outburst of power and testosterone started one almighty scrap.

By all accounts, the titanic battle was reminiscent of Muhammad Ali and Joe Frazier's Thriller in Manila heavyweight title fight, with huge forearms throwing punches that, as Frazier put it in 1975, could knock a wall down.

While the battle went on, the female watched. But far from supporting her chosen mate, she merely awaited the victor with keen but unbiased excitement. She didn't have to wait long. As quickly as the fight started, it was over. The interloper had prevailed and, without a gesture of goodbye, the female upped and left with her new mate.

One male confined a female for a fortnight. When she attempted an escape, he blocked her path and shepherded her back up the ridge.

When competition arrives, events can turn ugly. My biologist friend told me about an encounter he'd had in Katmai National Park one spring. A large lone male swaggered into a

This encounter dispels the theory that bears are entirely monogamous during mating, although this may be the case in areas of less dense populations.

Copulation begins with the male mounting the female, gripping her in a bear hug; it lasts a few seconds but may include several bouts lasting up to an hour. Each series of bouts is interspersed with rest and sleep. When they're done, the couple separate and the male plays no further part in the birth or nurturing of the cubs.

It's also possible that the female will mate again with a second partner, although a short period of oestrus (16–50 days) means there's a good chance she will be out of oestrus before encountering another male. If she does meet another male in a short space of time, however, it's possible that she will give birth to cubs with different fathers.

Although she is now pregnant, there's no guarantee that the female will give birth, because implantation is delayed. At first the embryos float

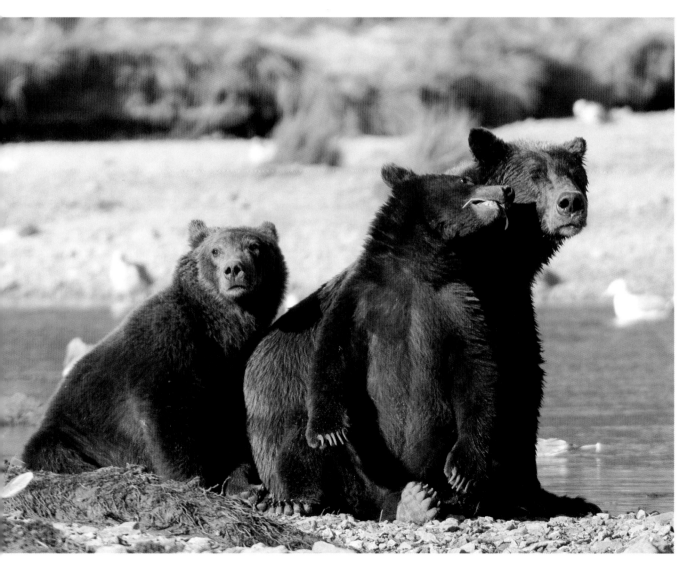

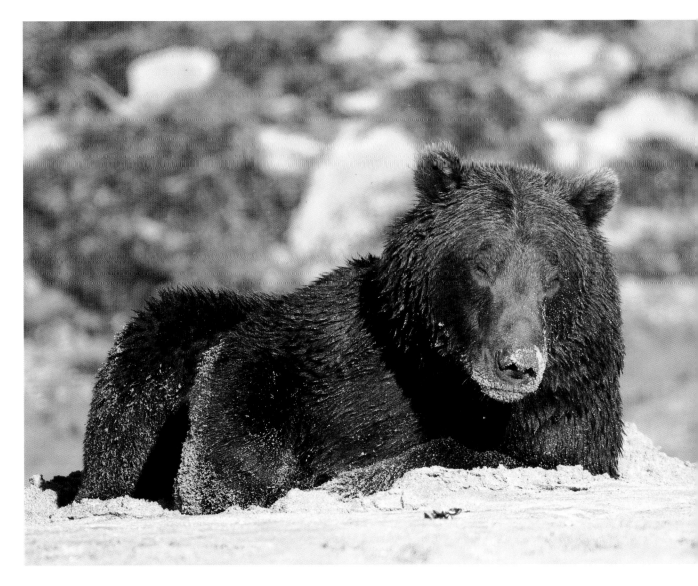

freely in the uterus and development is delayed until autumn. Only if the female has stored enough fat reserves to support both herself and her cubs during hibernation are the embryos implanted in the uterine wall to continue development. If the female's energy store is low, the pregnancy is terminated and the embryos absorbed into her body.

Pregnant bears den early. While she sleeps, in the middle of winter, a female gives birth to between one and four cubs (typically two), the exact number often determined by her experience and health. The cubs are hairless,

Above: Spring is a tiring time for mothers, who will often rest during the day.

Opposite: On average bears give birth to two cubs.

blind and weigh about half a kilo (1 lb). To survive, they snuggle against their mother's warmth and suckle on her fat-rich milk.

Three weeks later the cubs will open their eyes and by mid-April/early May they will have gained 3–4 kg (6.5–9 lb). It is now that cubs-of-the-year leave the den for the first time, initially staying close to their mother while exploring their outdoor home and getting to know each other.

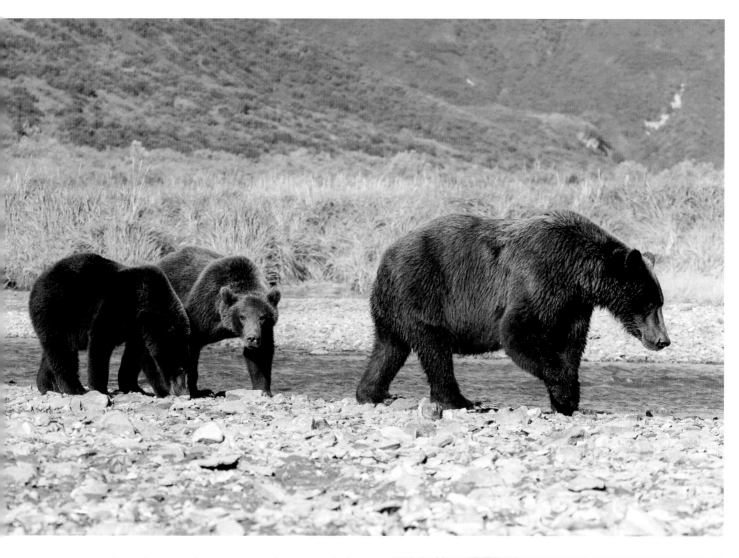

Over the next three years, cubs stay with their mother, who won't mate again until they are weaned (or die). During this time, the youngsters learn to recognise the best foods and how and where to find them. Along the coast, they learn how to fish for salmon. They learn survival and escape-and-evade techniques, necessary to protect them from harsh conditions and cannibalistic males. Then, at around three years, the young bears will leave the family, chased away by their mothers or simply abandoned.

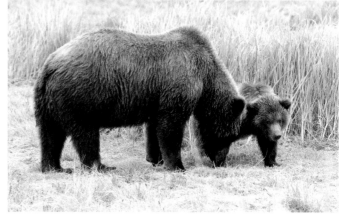

Opposite: Cubs stay with their mother for three years.

Below: A mother watches over her two cubs from a distance.

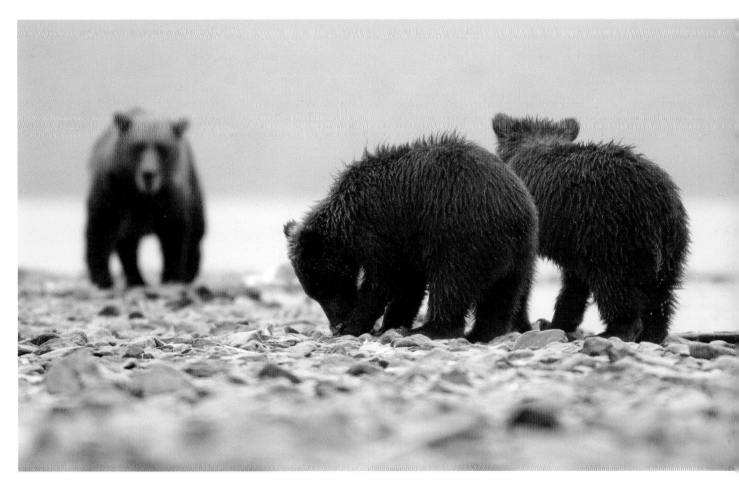

Opposite: In their early years, cubs learn which foods are edible and which to avoid.

Right: An older cub attempts to steal a fish from its mother. It won't be long before the cub is pushed out to fend for itself.

Far right: Cub mortality is high, with around a 50 per cent survival rate in the first year.

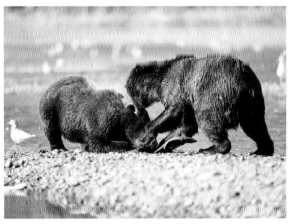

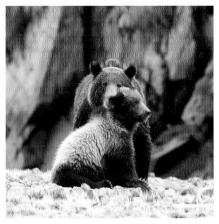

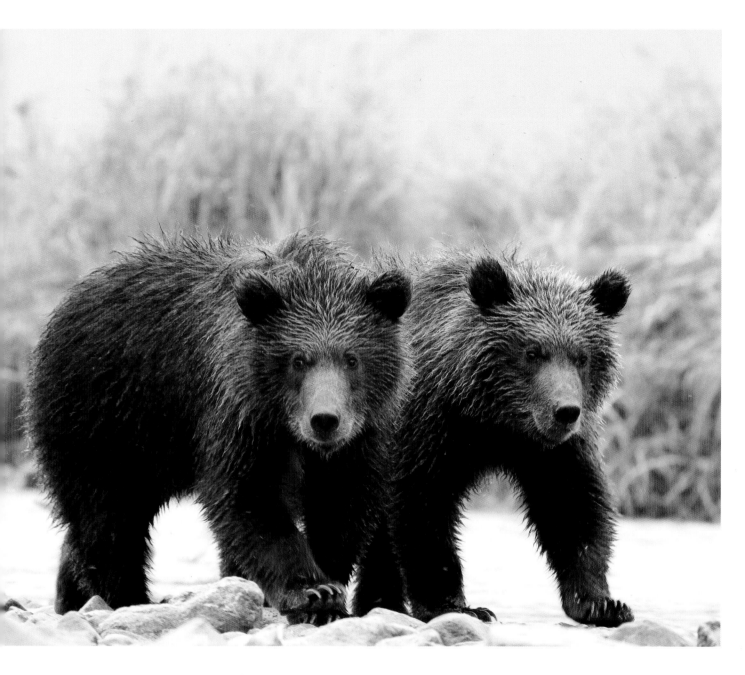

Above: Bear cubs must quickly learn the art of survival if they are to live to see adulthood.

Opposite: At around three years, cubs are pushed out and must now survive on their own.

After leaving their mother, the newly independent bears – referred to as sub-adults – disperse widely, probably to avoid conflict with older, more dominant bears. Although their chances of survival are much improved now, mortality rates are still high (around one in five for females and one in four for males). Starvation, traumatic injury and hunting are the main causes of fatalities in this age range.

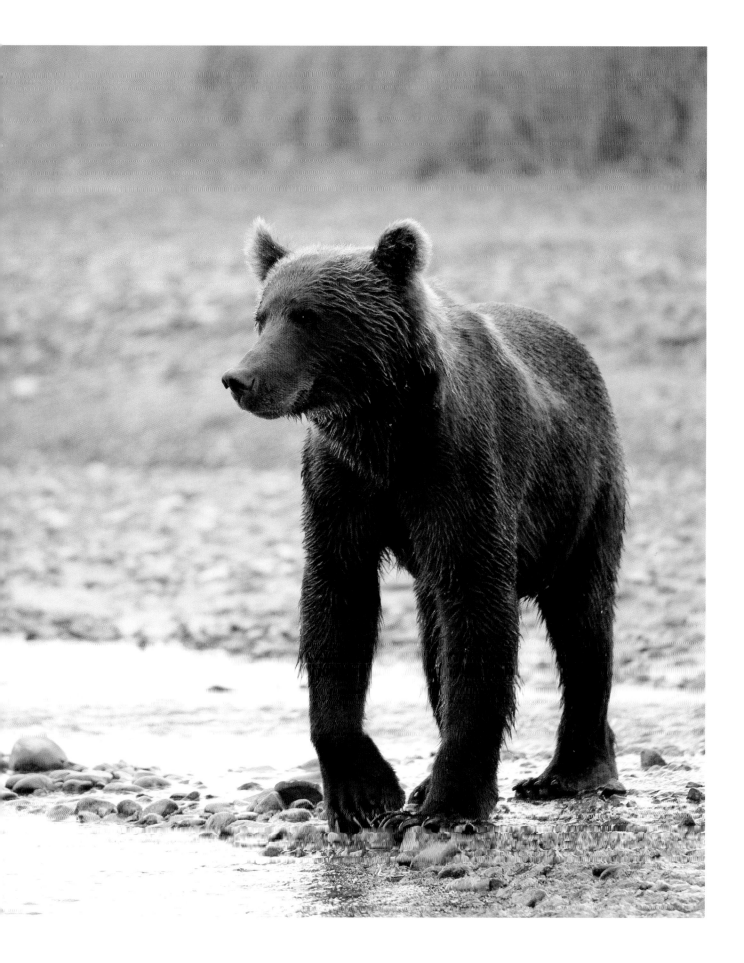

Bears in the environment

Home ranges extend over several hundred square kilometres and yet bears never get lost. One reason is that they have an astounding capacity for knowledge.

My bear biologist friend once conducted an experiment. In a controlled environment he set up a mock campsite in a distant, hidden location, leaving a few morsels of food in a tent. When two bears were introduced to the area they took several hours to find the fake camp. Exactly one year later, the experiment was replicated with the same two bears. This time, they headed straight for the 'campsite', locating it in minutes.

In another example, a wild bear with cubs was known to walk 32 km (20 miles) to a favoured oak tree to feast on acorns. Five years later, her cubs (now adults) were seen at the same tree.

Bears are eager students with life-long memories. From an early age, mothers teach their cubs survival skills. In particular, the youngsters must learn about plants – when to eat them and which ones to avoid. This knowledge will stay with them forever. Bears also learn about getting from A to B and will follow memorised routes between locations throughout their lives.

Another reason bears never get lost is their ability to navigate. It's believed they are able to detect the Earth's magnetic field, which provides them with a magnetic map of their world and a compass to find their way around.

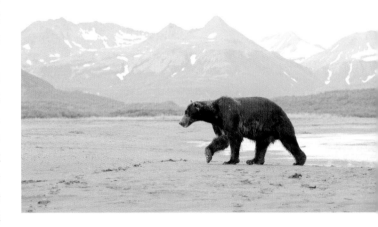

Above: Home ranges are large, covering hundreds of square kilometres.

Below: Bears will utilise the same trails over many years.

Opposite: It is believed that bears navigate using Earth's magnetic field.

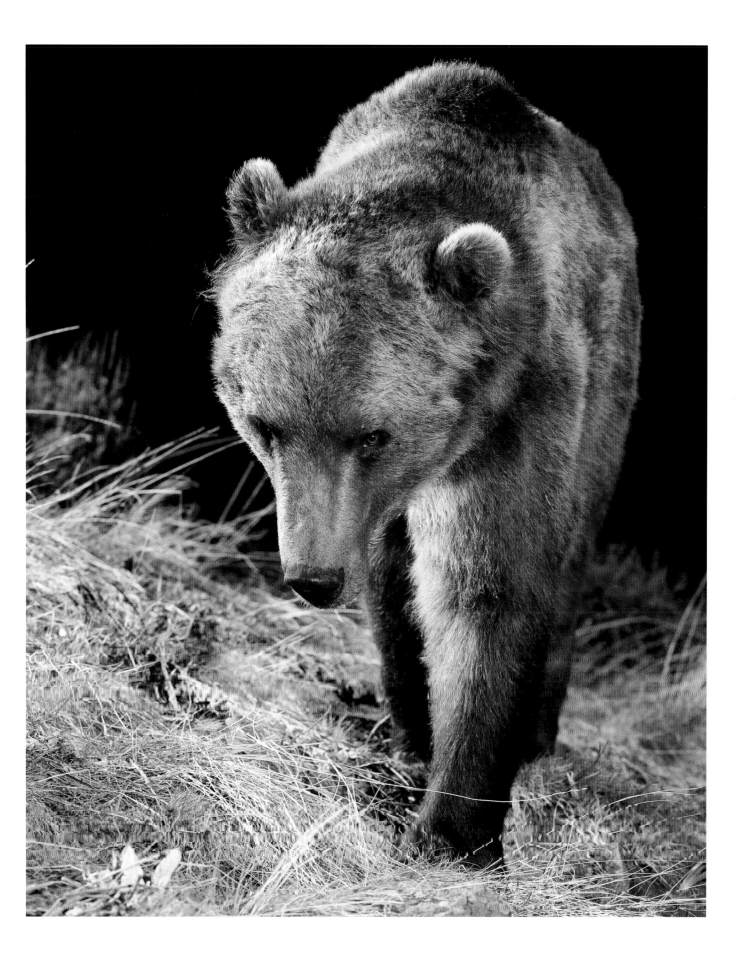

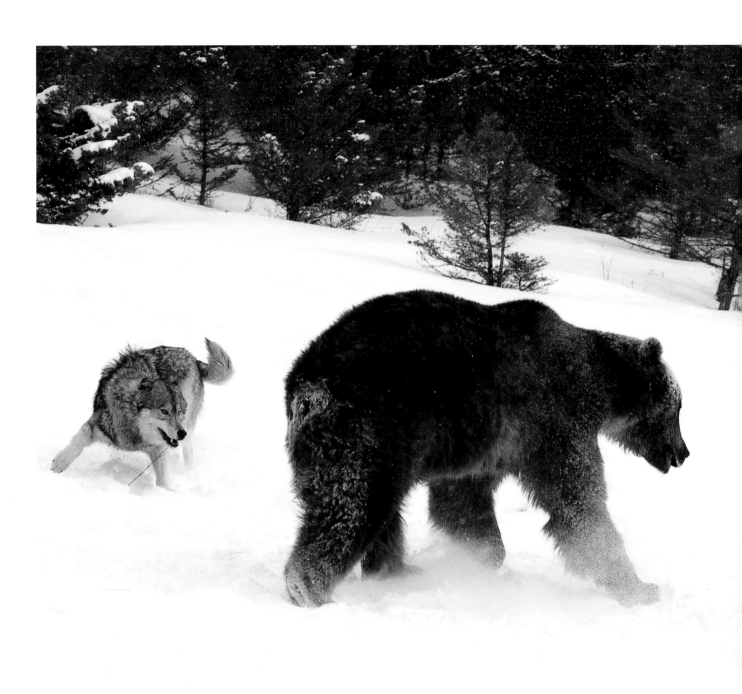

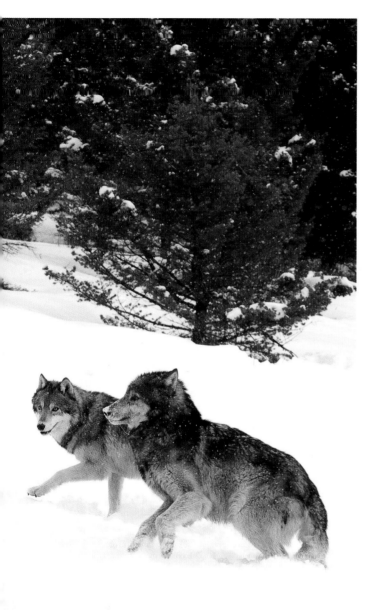

Predatory relationships

Brown bears share their home range with other carnivores, including wolves, black bears, mountain lions (cougars) and, in some regions, polar bears (in the Arctic) and tigers (in Asia).

Wolves have long been bears' principal rivals across most of their range. Interactions usually occur because of food, typically over the carcass of an elk or similar-sized prey killed by the wolf pack. Wolf/bear confrontations rarely result in death or serious injury: instead, the weaker party generally retreats.

Left: Wolves have long been bears' principal rivals across much of their range.

Below: A wolf confronts a bear that has stolen the pack's kill.

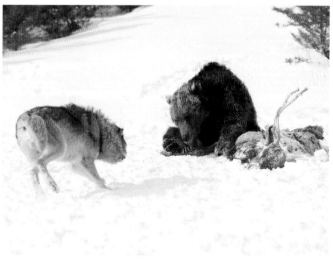

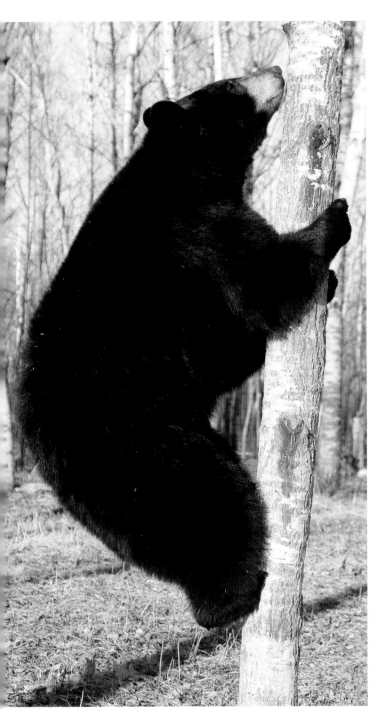

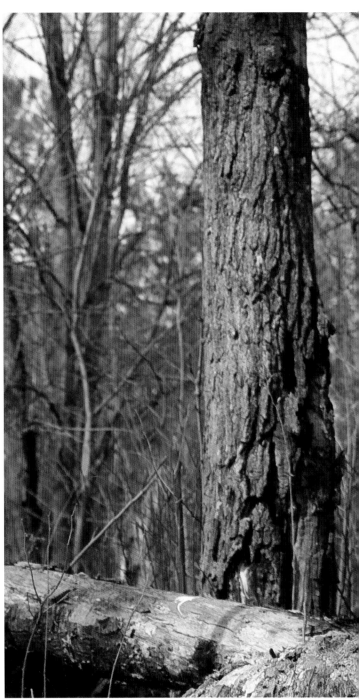

Above: In North America, brown bear ranges often overlap with those of black bears.

Above right: Brown bears and cougars rarely encounter one another, the large cat typically preferring to avoid confrontation.

Although black bears avoid brown bear territory, grizzlies are known to encroach on black bear terrain in search of food. Violent confrontations are uncommon, however. Black bears being much smaller, they typically run away or scamper up the nearest tree.

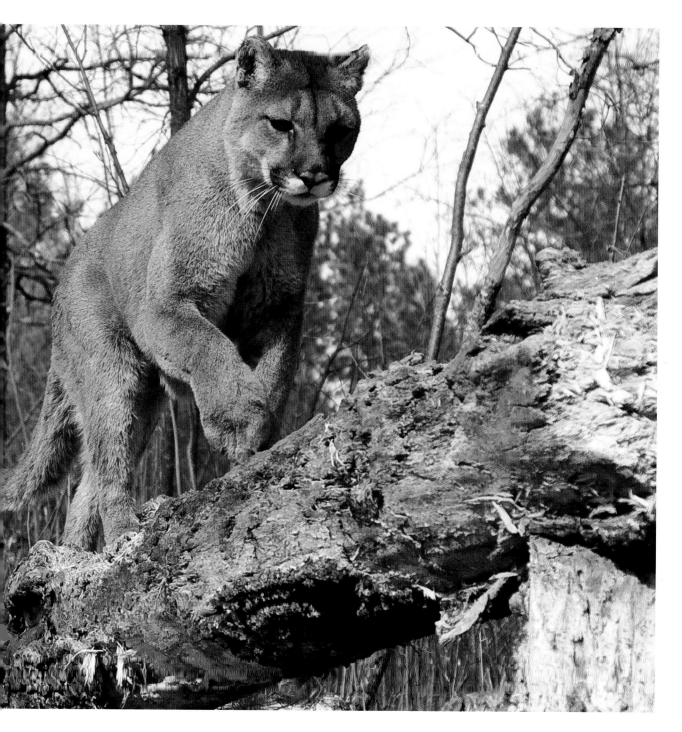

Mountain lions similarly avoid confrontations. If a bear scavenges a cougar's kill, the cat may try to harass the bear, using its agility to keep out of reach. Eventually, however, the cat will yield and move away.

In Russia, tigers are a threat and brown bears constitute around 5 per cent of a tiger's diet. An attack usually takes the form of an ambush, the tiger using its fearsome jaws to immobilise the bear before killing it. This type of predation generally occurs because of a decline in ungulate species, the tiger's more usual prey.

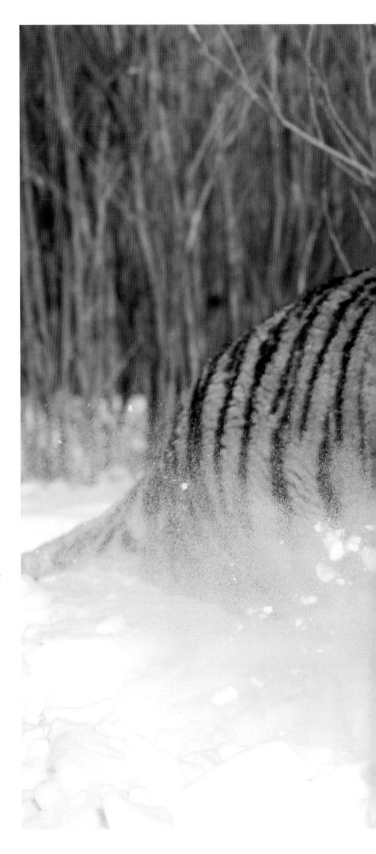

Biologists have observed bears changing their path after coming across tiger trails, as well as bears following tiger tracks with no signs of fear and even sleeping in abandoned dens. And, despite the threat of predation, some brown bears actually benefit from the tiger's presence by scavenging the cats' kills.

Brown bear/polar bear interactions are increasingly common, if still relatively new. They have been seen feeding harmoniously on shared prey, such as walruses and some whale species. Of the two, the brown bear is the stronger and more aggressive and the more likely to chase off its competitor.

There have also been occurrences in the wild of the two species interbreeding, producing hybrid cubs. Interestingly, because females ovulate only after spending several days with a male before mating numerous times over a number of days, mating between polar bear and grizzly is unlikely to be simply the result of a chance encounter.

Right: In Russia, tigers are a threat to brown bears.

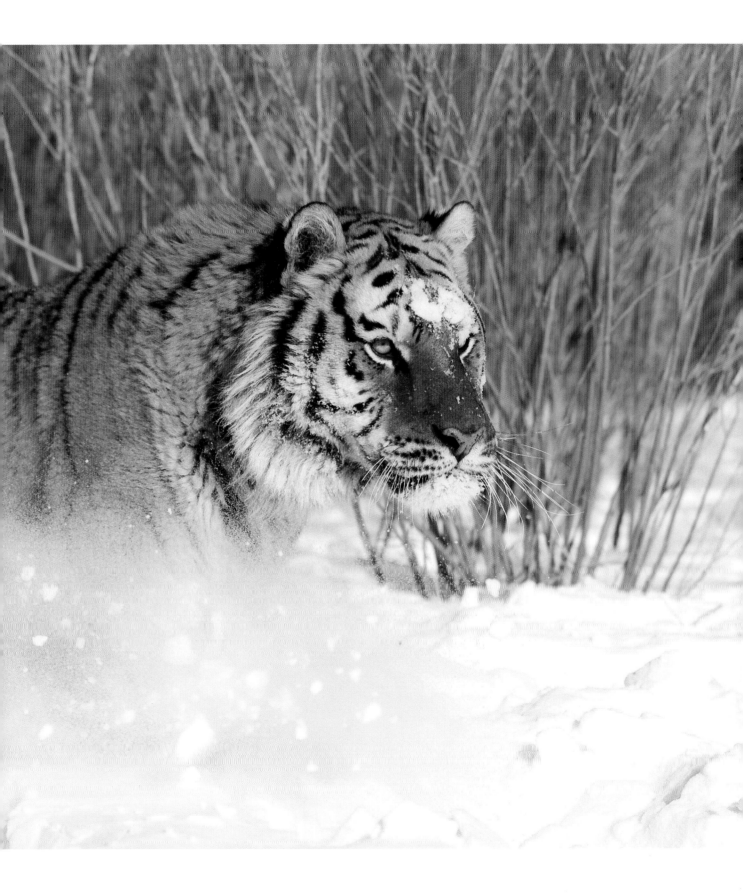

Bears and humans

In areas of wilderness, bears and humans co-exist under the umbrella of mutual respect. For example, in Alaska I have watched fishermen stand within a few hundred metres of bears fishing the same stream.

Human tolerance of bears diminishes, however, when bears encroach into developed areas, particularly around livestock and towns and villages. Cattle ranchers and livestock farmers in North America and Europe see bears as a threat to their livelihoods and, over the years, have been largely responsible for the eradication of bears from large portions of their historic range. More recently, through education by groups such as the Grizzly Bear Outreach Project in Washington State, people are relearning how to co-exist with bears.

In urban areas, bears' highly adapted memories can be their undoing. Bears that come into contact with human environments will quickly learn how to scavenge food from rubbish bins, from inside vehicles and even from dog bowls left out on porches. Once a bear has discovered easy pickings it will remember where to find them for the rest of its life and, ultimately, will often suffer a premature death because of it.

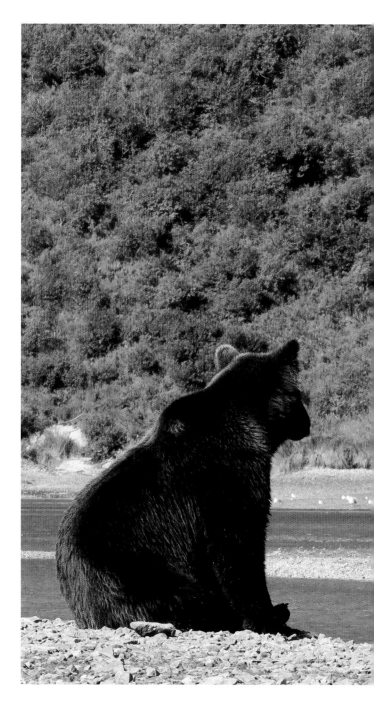

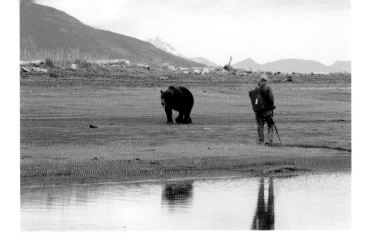

Left: A boar passes a lone photographer but shows no interest in him.

Below: In Alaska's Katmai National Park, bears share the environment peacefully with humans.

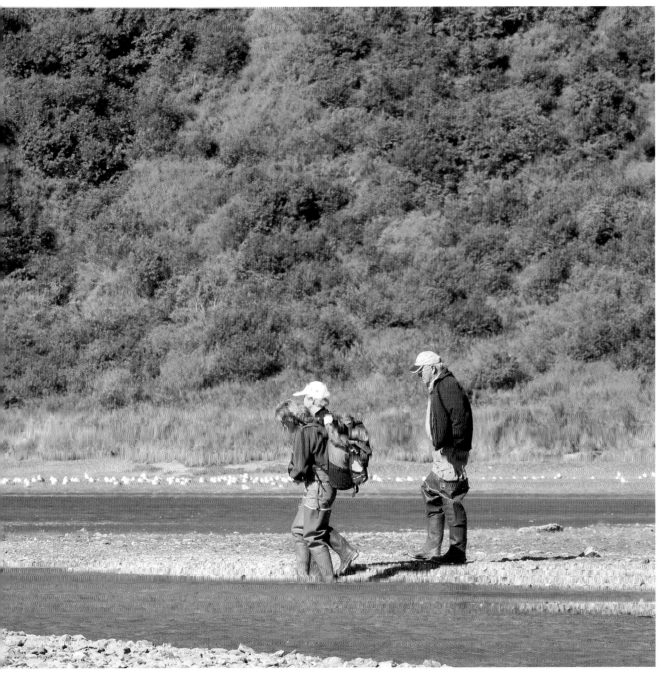

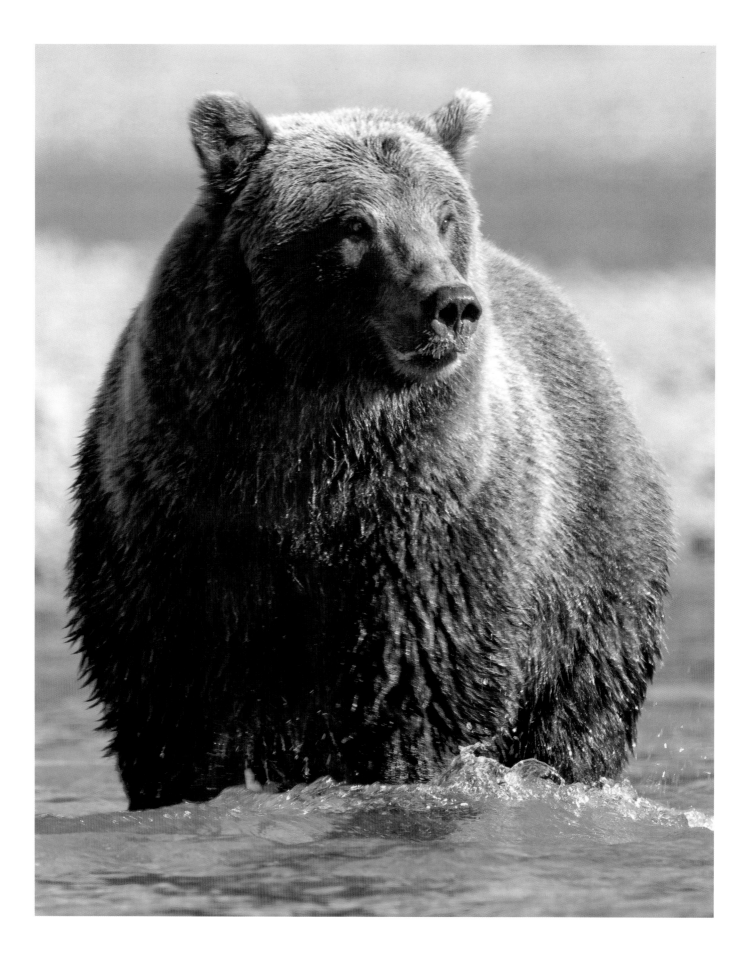

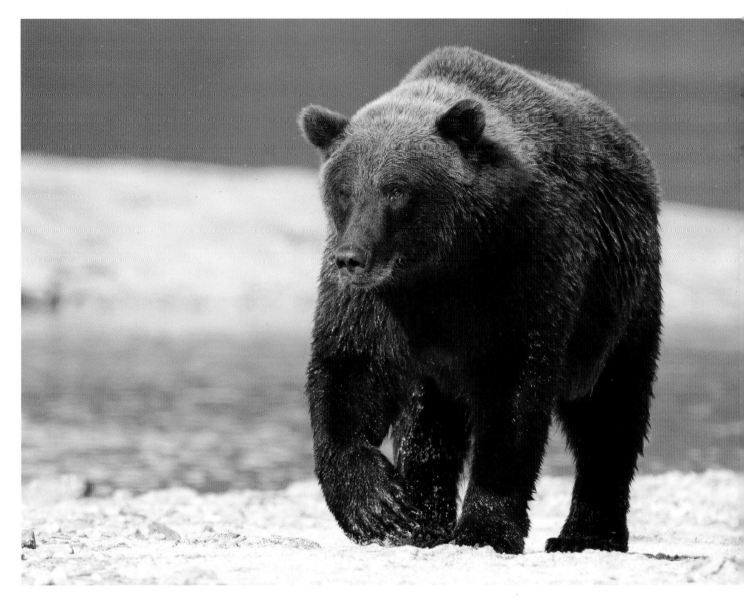

Attacks on humans are uncommon, but they do occur. Most are defensive attacks, where the bear is responding to a perceived threat. Since 2000, records show ten human fatalities caused by brown bears in North America, the most notable being the death of self-styled 'Grizzly Man' Timothy Treadwell and his girlfriend in Katmai National Park. Treadwell was a controversial character and feelings about the cause of the fatal attack are divided. What is true to say is that these two deaths were the first ever recorded in the park.

In addition to hunting, human caused

Above: Education has enabled people to co-exist more peacefully with bears.

Opposite: Despite the sheer size of bears, attacks on humans are rare and are generally a defensive response to inappropriate human behaviour.

mortality is a major threat to bears. Transport routes – road and rail – through areas of wilderness are a primary cause of deaths, bears being run down by trains as they scavenge for grain between the tracks, or by road vehicles as they cross between divided feeding areas.

Conservation

Bears are listed as Least Concern by the IUCN, meaning they are at low risk of extinction. However, they are listed as threatened in the contiguous United States and endangered in parts of Canada, where some populations, such as those in Alberta, Saskatchewan and Manitoba, have become locally extinct.

Despite this, in 2006, the US Fish and Wildlife Service proposed to remove bears in Yellowstone National Park from the list of threatened and protected species, and de-listed the population, effectively removing Endangered Species Act protection. However, a federal judge reinstated protection for the bears three years later.

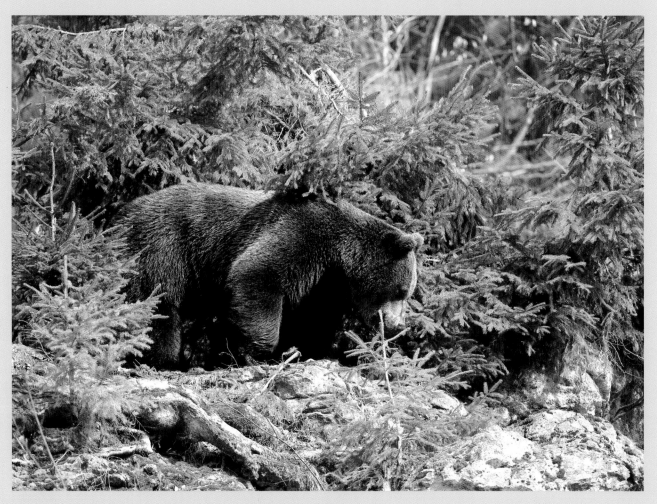

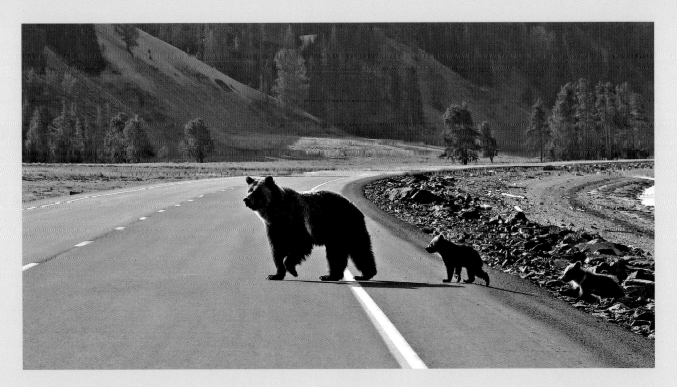

Within the United States, conservation efforts are concentrated around restoring bears in six primary recovery areas: the Northern Continental Divide in Montana, Yellowstone National Park, which crosses into Montana, Wyoming and Idaho, Cabinet-Yaak and Selway-Bitterroot (both within Montana and Idaho), Selkirk (Idaho and Washington) and Washington's North Cascades. The total bear population in these areas is currently estimated at around 1,500 animals.

In European Union (EU) countries, bears are listed as European Protected Species and are protected by law under the European Habitats Directive. Regionally, in Spain, the *Catálogo Nacional de Especies Amenezadas* lists the country's population of bears as in danger of extinction. In 2007, the Cantabrian population was estimated at around 170, divided between 140 in the western section and 25–30 in the eastern.

In Italy, however, where bears appeared to be close to extinction because of hunting, poaching and retributive killing, conservation efforts have seen some success, with dozens of cubs having been born in recent years.

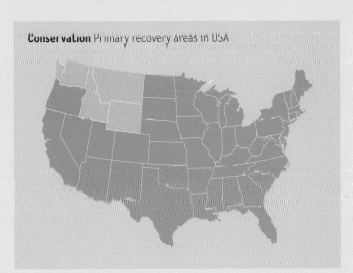

Conservation Primary recovery areas in USA

Above: Yellowstone National Park is once again an area where conservation activities are concentrated

Opposite: Bears in many parts of Europe are classified locally as threatened.

Watching bears

Brown bears are fascinating and captivating creatures – highly intelligent, inquisitive, playful, mischievous and alluring. Many tour operators around the world make a healthy living offering 'adventures' that allow people to spend time watching and photographing them.

In North America, the best place to see brown bears is Katmai National Park, lying southwest of Anchorage in Alaska, during the annual salmon migration. It's here, in mid-summer, that large groups of bears congregate along the Brooks River and at the famous Brooks Falls, close to Brooks Camp, where leaping salmon run the gauntlet of snapping jaws and sharp claws. It is a spectacle every bear lover should witness, but be prepared for a heavily commercialised operation, with hundreds of day-trippers joining overnight campers in the mêlée to watch the action on purpose-built platforms.

Further south, towards the coast, along the Katmai Peninsula, and later in the season (August/September), hardier adventurers will find an opportunity to watch bears in a more remote, less manic, less regimented setting. Here, with the giant Brooks Range as a backdrop, bears patrol the inlets off the Shelikof Strait, from Geographic Harbor to Hallo Bay, feasting on the healthy supply of sockeye salmon. This area is harder to access than Brooks Falls, but its isolation and sense of scale make it a more rewarding experience.

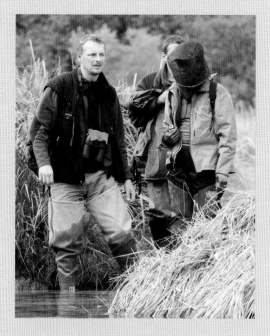

Above: My buddy Chris Morgan leads a small tourist group in Katmai National Park.

Opposite: Brooks Falls, close to Brooks Camp in Alaska, is a favoured destination for bear-loving tourists.

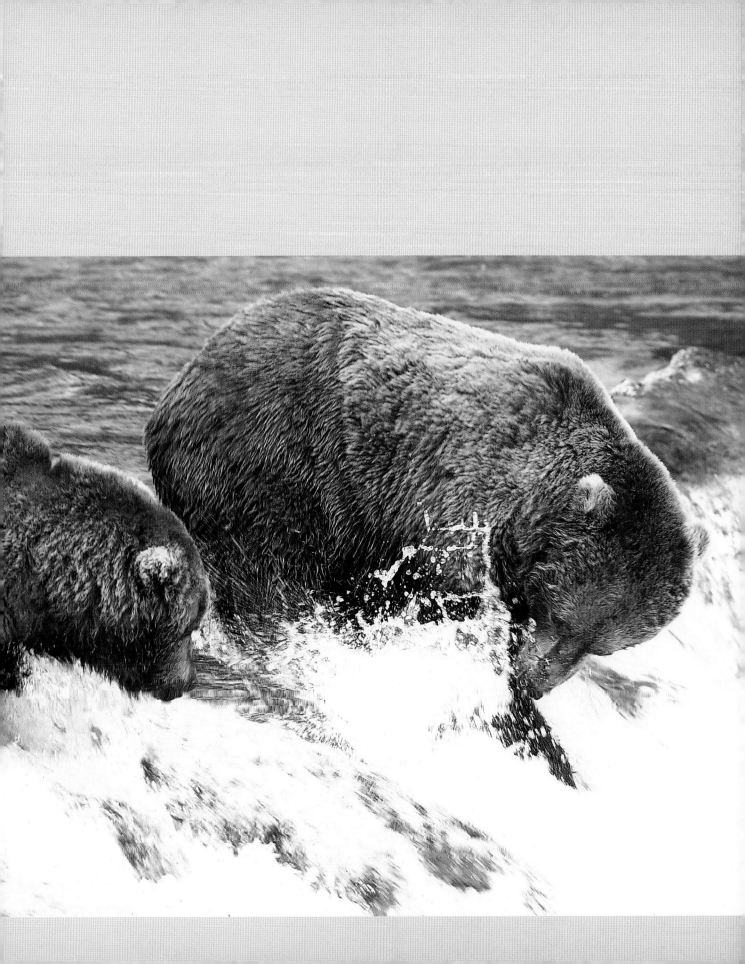

Both locations are reached from Anchorage via either Kodiak Island (for the Peninsula) or the small town of King Salmon (for Brooks Camp) by floatplane. Brooks Camp provides overnight accommodation for limited periods in wooden chalets, as well as a campground. On Katmai Peninsula you have either to sleep on a chartered tourist boat or to camp wild.

Other popular bear-watching destinations in North America include the McNeil River State Game Reserve in Alaska (where ten permits for a two-and-a-half-day visit are awarded through a lottery run by Alaska Department of Fish & Game; three standby permits allow visitors to camp in the area and participate in viewing should a spot open up), Knights Inlet in British Columbia, Canada, and Kodiak Island, Alaska, where tourists can see the largest of all the brown bears.

Bear-watching in Europe is less certain: sightings in the south, north and east of the continent are rare and unpredictable. For more guaranteed viewing, try Martinselkonen Nature

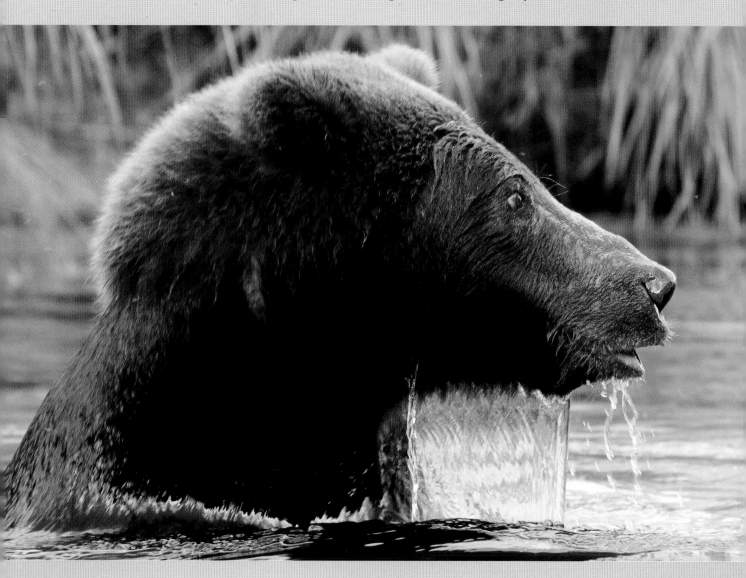

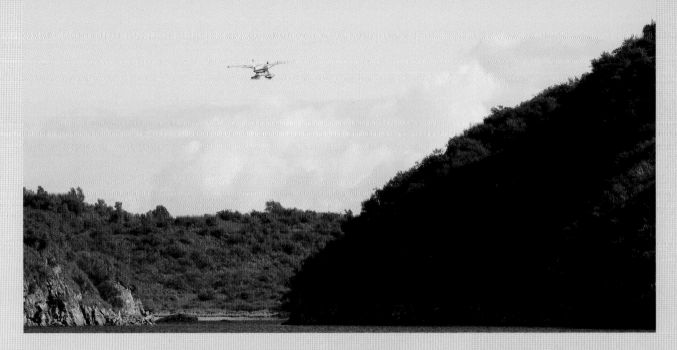

Reserve in Finland, close to the Russian border. It is accessed from either Oulu (300 km/190 miles) or Kuusamo (100 km/62 miles) and the season is similar to that of North America, between mid-July and mid-August. Bear-viewing in Martinselkonen is enhanced by the provision of hides.

Russia's bears are best viewed in the far east of the country, on the Kamchatka Peninsula, where they are very similar to those found in Alaska. August is the best season and the highest concentration of bears is usually found around Kurilskoye Lake in Yuzhno-Kamchatsky Reserve, which is reached via Petropavlovsk-Kamchatsky Airport. Very basic tourist cabins are available.

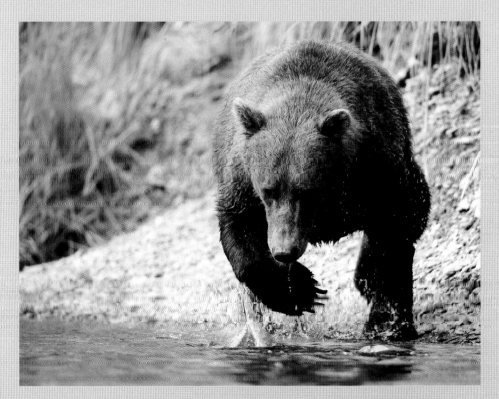

Above: After depositing me on the Katmai Peninsular my 'taxi' heads back to Kodiak Island.

Left: Bear-watching in Russia is less commercialised and logistically harder than in the US and Canada, but equally rewarding.

Opposite: There are several locations in North America where bears can be observed safely.

Bear facts

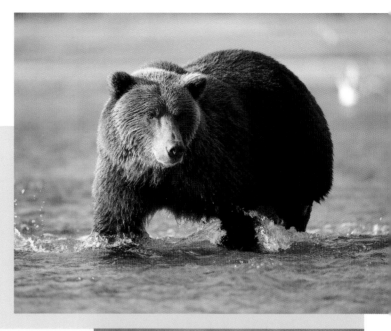

Classification

Kingdom	Animalia
Phylum	Chordata
Class	Mammalia
Order	Carnivora
Family	Ursidae
Genus	*Ursus*
Scientific name	*Ursus arctos*
IUCN Red List status	Least Concern (LC) v.3.1

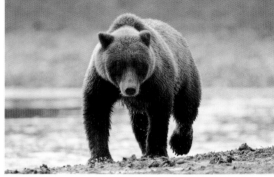

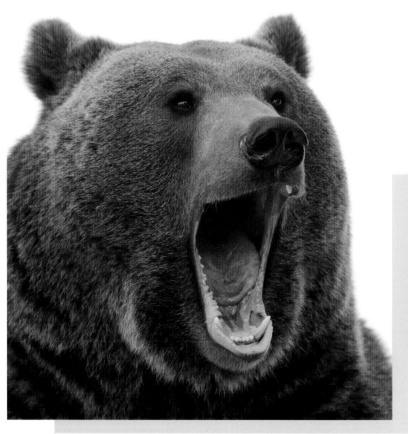

Physiology (average)

Height	1 m (3.25 ft) at the shoulder
Weight – adult males	135–390 kg (300–860 lb)
Weight – adult females	95–205 kg (210–450 lb)
Variations	The largest recorded brown bears exist on Kodiak Island, Alaska. European bears are typically smaller.

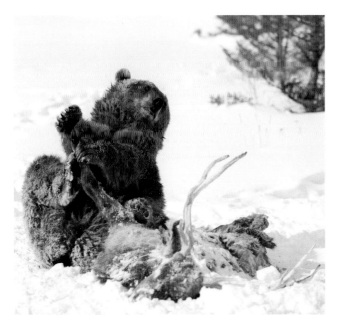

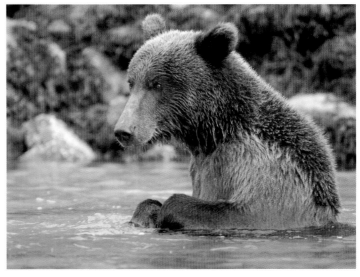

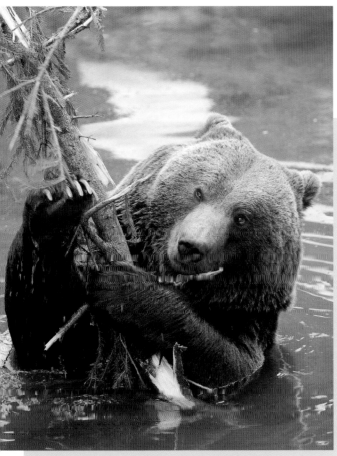

Ecology

Gestation period	180–265 days (with delayed implantation)
Litter size	1–4 cubs, typically 2
Dispersal age	36 months
Sexual maturity – males	8–10 years
Sexual maturity – females	4.5–7 years
Life span	20–30 years in the wild
Diet	Varies depending on habitat: vegetation (grasses, sedges, bulbs, roots, berries, nuts), insects, fish, small mammals and large mammals, such as caribou and elk
Habitat	Wide ranging, from subalpine mountain to tundra and dense forest
Distribution	Europe, north, central and southwest Asia, Japan, and North America

Useful information

Recommended reading

Janine M Benyus, ***The Secret Language and Remarkable Behaviour of Animals*** (Black Dog & Leventhal Publishers, 2002)

Matthias Breiter, ***The Bears of Katmai*** (Graphic Arts Center Publishing Company, 2001)

Matthias Breiter, ***Bears – a year in the life*** (Firefly Books, 2005)

Lance Craighead, ***Bears of the World*** (Voyageur Press, 2000)

John Sparks, ***Realms of the Russian Bear*** (BBC Books, 1992)

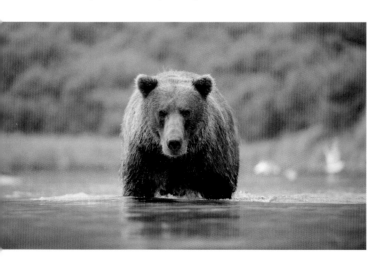

Useful websites

• **Chris Weston**
Wildlife photographer and photojournalist
www.chrisweston.uk.com

• **Martinselkosen Eräkeskus**
A wildlife centre in the midst of the great Kainuu wilderness in Finland.
http://www.martinselkonen.fi/index. php?id=1&la=en

• **Brooks Camp – Katmai National Park**
Situated at the mouth of the Brooks River, Brooks Camp attracts visitors of all kinds to view brown bears.
http://www.nps.gov/katm/planyourvisit/ brookscamp.htm

• **Katmai National Park**
Katmai is famous for its brown bears, pristine waterways with abundant fish, remote wilderness and rugged coastline.
http://www.nps.gov/katm/index.htm

• **McNeil River State Game Sanctuary**
Lottery-managed bear-viewing.
http://www.wc.adfg.state.ak.us/ index.cfm?adfg=wildlife_news.view _article&articles_id=110&issue_id=22

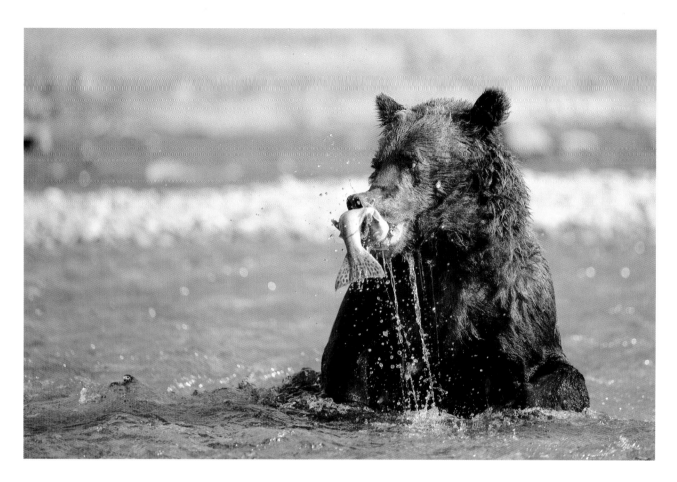

Tips for bear photography

- Head for a location where bear sightings are more or less guaranteed, such as Brooks Camp in Katmai National Park, Alaska, and Martinselkosen Fräkeskus in Finland.

- A long telephoto lens will allow you to capture frame filling images without getting close to the subject.

- Use fast shutter speeds to freeze action shots.

- Use a slow shutter speed to capture a sense of movement.

- For portrait shots, use a wide lens aperture to blur background detail and isolate the subject, making it stand out.

- Use short focal-length lenses to create images that show a sense of place and the environment.

- In low light, increasing ISO will help to maintain faster shutter speeds.

- Focus on the eyes.

- Photograph bears at eye level for a more engaging composition.

- Stay aware of opportunities to photograph specific bear behaviour, particularly in areas where bears congregate.

- Never feed bears in order to entice them closer – it will endanger their lives as well as yours.

Above and opposite: There are parts of the world where bear sightings are almost guaranteed.

Other Wildlife Monographs titles published by

Evans Mitchell Books

www.embooks.co.uk

Wildlife Monographs
Snow Monkeys
ISBN: 978-1-901268-37-9

Wildlife Monographs
Living Dinosaurs
ISBN: 978-1-901268-36-2

Wildlife Monographs
Giant Pandas
ISBN: 978-1-901268-13-3

Wildlife Monographs
Monkeys of the Amazon
ISBN: 978-1-901268-10-2

Wildlife Monographs
Polar Bears
ISBN: 978-1-901268-15-7

Wildlife Monographs
Cheetahs
ISBN: 978-1-901268-09-6

Wildlife Monographs
Loepards
ISBN: 978-1-901268-12-6

Wildlife Monographs
Sharks
ISBN: 978-1-901268-11-9

Wildlife Monographs
Penguins
ISBN: 978-1-901268-14-0

Wildlife Monographs
Elephants
ISBN: 978-1-901268-08-9

Wildlife Monographs
Dolphins
ISBN: 978-1-901268-17-1

Wildlife Monographs
Wolves
ISBN: 978-1-901268-18-8

Wildlife Monographs
Puffins
ISBN: 978-1-901268-19-5